NORTHBROOK PUBLIC LIBRARY
NORTHBROOK, IL 60062

MAY 1 2 2010

Northbrook Public Library

3 1123 00915 3480

W9-AAC-226

fardif phua lacdma.
rcelphia.

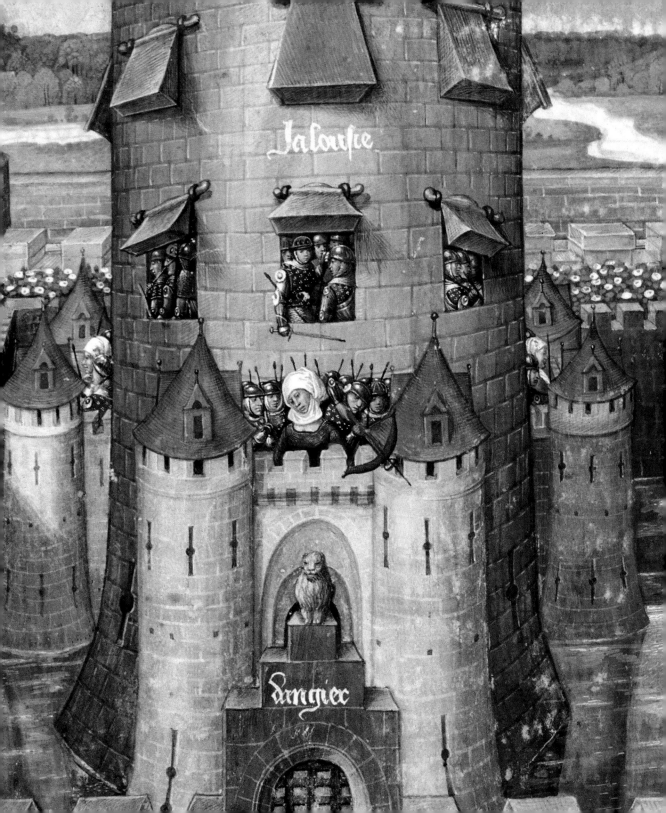

THE MEDIEVAL IMAGINATION

Building

THE MEDIEVAL WORLD

CHRISTINE SCIACCA

THE J. PAUL GETTY MUSEUM
THE BRITISH LIBRARY

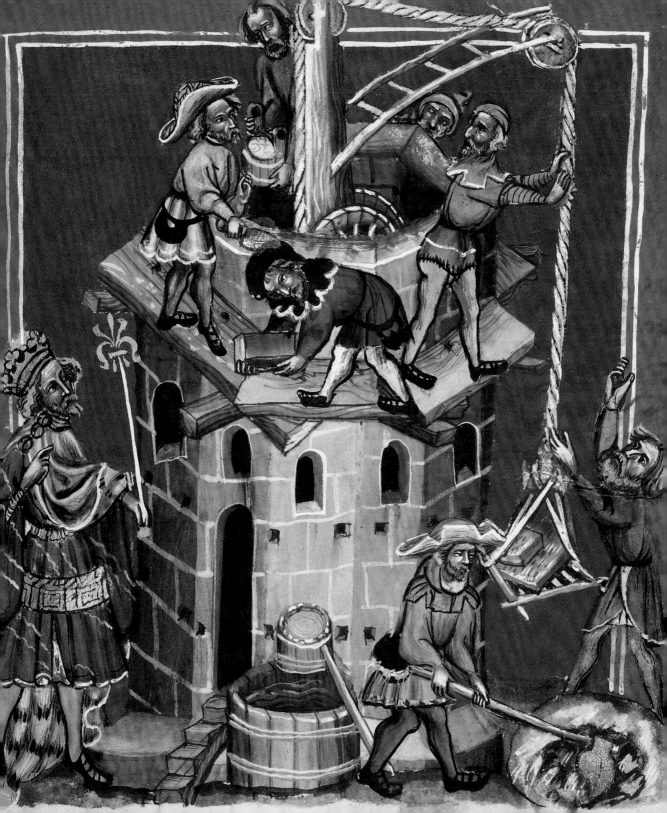

© 2010 J. Paul Getty Trust

Published by the J. Paul Getty Museum, Los Angeles

Getty Publications
1200 Getty Center Drive, Suite 500
Los Angeles, California 90049-1682
www.getty.edu/publications

Gregory M. Britton, *Publisher*
Elizabeth Morrison, *Series Editor*
Mollie Holtman and Beatrice Hohenegger, *Editors*
Cynthia Newman Bohn, *Copy Editor*
Kurt Hauser, *Designer*
Amita Molloy, *Production Coordinator*
Rebecca Vera-Martinez, *Photographer*

Published in Europe in 2010 by
The British Library
96 Euston Road
London NW1 2DB
www.bl.uk

Printed and bound in Singapore by Tien Wah Press

Library of Congress Cataloging-in-Publication Data

Sciacca, Christine, 1976–
 Building the medieval world / Christine Sciacca.
 p. cm.—(The medieval imagination)
 ISBN 978-1-60606-006-3 (hardcover)
 1. Architecture, Medieval. 2. Architecture and society—Europe.
 3. Architecture, Medieval, in art. 4. Illumination of books and
 manuscripts, Medieval. I. Title.
 NA350.S35 2010 723—dc22
 2009030011

British Library Cataloging-in-Publication Data
A catalogue record for this book is available from the British Library
ISBN 978-0-7123-5094-5

Front cover: Detail of *Medieval German Town* (fig. 11); background, detail of *Canon Table Page* (fig. 80).

Back cover: Detail of *Ladies Building Their City* (fig. 50)

Page i: Detail of *The Castle of Jealousy* (fig. 51)

Frontispiece: Detail of *The Construction of the Tower of Babel* (fig. 26)

Sources for Quotations
Page 31 [in fig. 26]: Genesis 11:4 (New American Standard Version [NASV])
Page 46 [in fig. 44]: Acts 2:1 (NASV)
Page 66 [in fig. 65]: John 13:16 (NASV)

The copyright of the illustrations is indicated by the initials JPGM (J. Paul Getty Museum) and BL (British Library).

Author's Acknowledgments
I have benefited greatly from the suggestions and feedback of Thomas Kren, Erene Morcos, Misa Kabashima, and Stephen Murray, my architectural mentor. I thank Michelle Brown for having given me the opportunity to become familiar with the British Library's collection during my employment there. I dedicate this book to my parents, Vic and Margaret Sciacca, without whom none of this would have been possible, and to Dominic Mimnagh.

Note to Reader
In the captions in this book, the title of the image under discussion appears first, with the title of the main image on the manuscript page in brackets beneath it.

CONTENTS

vii Foreword

1 Introduction: Architecture in Medieval Life

4 **MIRROR OF THE MEDIEVAL WORLD**

6 The Castle

10 Church Spaces

14 Medieval Cities, Towns, and Countryside

22 Documenting Historical Buildings

30 Medieval Construction Methods

34 Focus: Architecture Inside and Out

38 **ARCHITECTURE IN STORIES AND SYMBOLS**

40 Architecture in Scripture

52 Architecture in Medieval Literature

58 Saints and Their Architectural Symbols

61 The Virgin Mary and the Church

64 Focus: Architecture Takes Center Stage

68 **ARCHITECTURE BEYOND BUILDINGS**

72 Architecture in the Margins

76 Triumphal Arches and Niches of Honor

82 Framing Charts and Texts

86 Structuring Compositions

90 Focus: Architecture Abstracted

95 Suggestions for Further Reading

96 The Medieval Imagination Series / About the Author

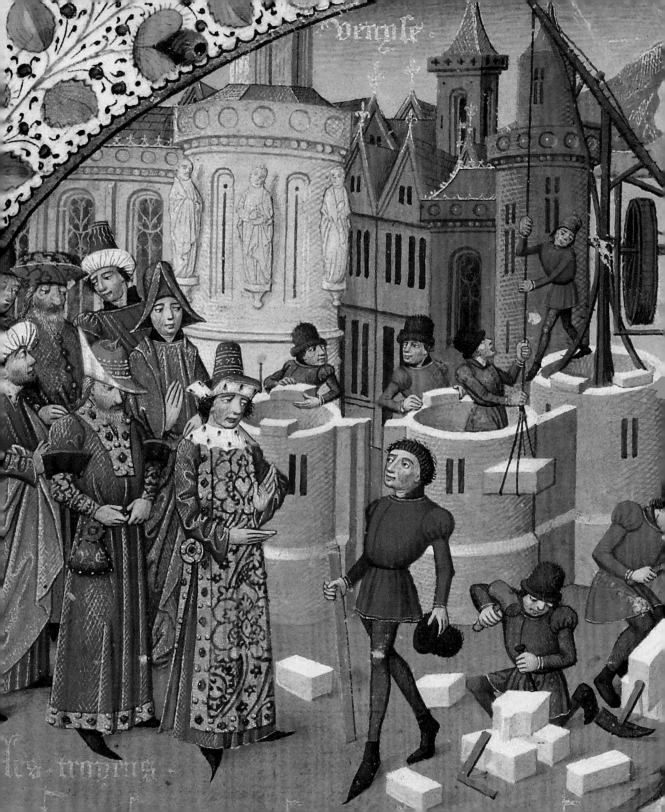

The soaring nave, radiant stained glass, and flying buttresses of Notre Dame in Paris have come to epitomize today medieval art, medieval culture, for many indeed the medieval mind. *Building the Medieval World*—the fourth in the popular series *The Medieval Imagination*, which draws upon the collections of illuminated manuscripts at the J. Paul Getty Museum and the British Library—turns its attention not only to such iconic cathedrals but also to the broad spectrum of medieval architecture. While many medieval buildings are lost to posterity, a record of their magnificent appearance is often preserved within the pages of illuminated manuscripts. Here the creative ways in which architecture is represented offers a unique insight into what these buildings meant for men and women of the medieval era. They were not simply structures to inhabit—they symbolized grandeur, power, even heaven on earth.

The idea for this book grew out of a small exhibition on medieval architecture conceived and curated by Christine Sciacca, assistant curator of manuscripts at the Getty Museum. She readily agreed to a suggestion that a book in this series accompany the exhibition and produced it with great efficiency, learning, and panache. We would like to thank Rebecca Vera-Martinez, Michael Smith, and Johana Herrera for the superb photography of works from the Getty collection and Nancy Turner, Kristen Collins, Lynne Kaneshiro, Stephen Heer, Ron Stroud, and Erin Donovan for their part in the process of photography. Kurt Hauser, who conceived this series with Elizabeth Morrison, the series editor, designed this book with his characteristic sensitivity to manuscripts as art and also as windows onto another time. We are also grateful to Gregory Britton, Mark Greenberg, Amita Molloy, Beatrice Hohenegger, Cindy Bohn, Mollie Holtman, Anne Lucke, and Leslie Rollins at Getty Publications and David Way, Catherine Britton, Sally Nicholls, Kathleen Doyle, Andrea Clarke, and Justin Clegg at the British Library for their contributions to this volume and to the *Medieval Imagination* series.

Thomas Kren
Senior Curator of Manuscripts
The J. Paul Getty Museum

Scot McKendrick
Head of Western Manuscripts
The British Library

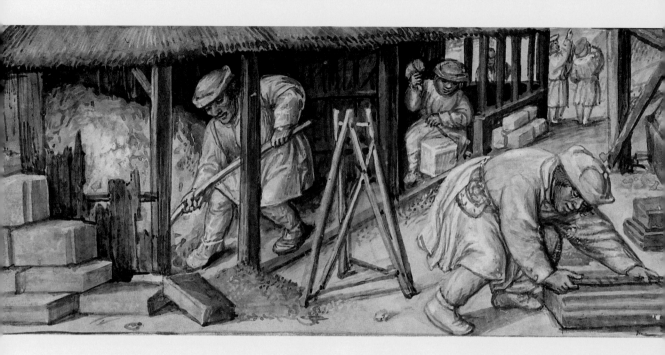

page iv:
Detail of *Construction
of Venice, Sycambria,
Carthage, and Rome*
(fig. 24)

Fig. 1 △ ▷
**The Construction of the
Tower of Babel**
Master of James IV of Scotland
Spinola Hours
Bruges and Ghent, ca. 1510–20
JPGM, Ms. Ludwig IX 18, fol. 32

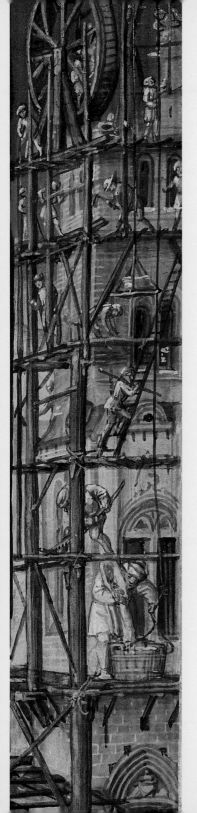

INTRODUCTION: ARCHITECTURE IN MEDIEVAL LIFE

Each day most people encounter architecture. We dwell in our homes, we occupy workplaces, and we walk by buildings on a daily basis. Indeed, we take the presence of most architecture for granted, not realizing that it literally structures our lives. This close connection between architecture and daily life was also true in the Middle Ages, a time when royalty held court in majestic castles, worshippers prayed inside soaring cathedrals, commerce was conducted in town squares surrounded by civic buildings and multifamily urban homes, and the fruits of the land were harvested in a system centered around the sprawling estates, farmhouses, and cottages of the countryside. The monumental architecture they found all around them so captivated medieval viewers that these buildings crept into the fictional world of the painted page. While a significant number of medieval buildings survive to the present day (in both their original and restored forms), many others have disappeared. Some of the best records we have of these architectural wonders, representing the greatest achievements of the Middle Ages and Renaissance, can be found in illuminated manuscripts.

Medieval artists incorporated examples of church and domestic architecture into scenes depicting stories drawn from scripture, literature, and history. In depicting stories from the Bible, artists sometimes attempted to re-create the appearance of Jerusalem in biblical times, but more often the settings reflect the architecture of the period when the manuscript itself was written and illuminated. This practice was partly due to a lack of knowledge of earlier forms of architecture outside Europe, but it was also purposeful. Presenting events that happened hundreds of years before in a contemporary setting was a way to make these stories come to life for medieval viewers, to make it seem as if the event could happen in their own town and in their own time.

The architecture that appears in the pages of manuscripts is not restricted to accurate representations of the buildings that filled the medieval world. Structures were manipulated in different ways to tell stories and to convey meaning. Because buildings were held in high regard, architecture was often used in a symbolic way to suggest the importance or holiness of an individual or event. Compositions that depict impressive architectural settings lend greater

1

significance to the people portrayed, such as a king commanding a vast palace hall or a saint placed like a sculpture within an architectural niche (fig. 78). If a particular building played a key role in an important event from a saint's life, the structure itself sometimes became a symbol or a stand-in for the holy person (fig. 55). Open cross-sections of multiroom interior spaces allowed artists to depict different episodes in a story within a single building, in much the same way as the frames of a movie show a progression of events through time.

Medieval illuminators also excerpted individual building elements and used them as decorative motifs in manuscript illumination. Columns and archways created bold frames for important texts and images alike. Elaborate tracery modeled after the minute architectural decoration found in Gothic church interiors fills the borders of the pages in books of hours (fig. 70). Arcades were used to organize the indexes in Gospel books, recalling the forms of portals into buildings and providing symbolic gateways into the texts that followed them (figs. 80 and 81).

This book offers an opportunity to look back at the architectural feats of the medieval world, which often form the basis for our own modern constructions, and encourages readers to stop and look up at the buildings that surround us and shape our lives every day.

Fig. 2 ◁
A King, a Queen, and a Maid in a Tower
Master of Guillebert de Mets
Book of hours
Probably Ghent, ca. 1450–55
JPGM, Ms. 2, fol. 18v

Fig. 3 ▷
Farmhouses
[November Calendar Page, Threshing and Pig Feeding]
Master of James IV of Scotland
Spinola Hours
Bruges and Ghent, ca. 1510–20
JPGM, Ms. Ludwig IX 18, fol. 6v

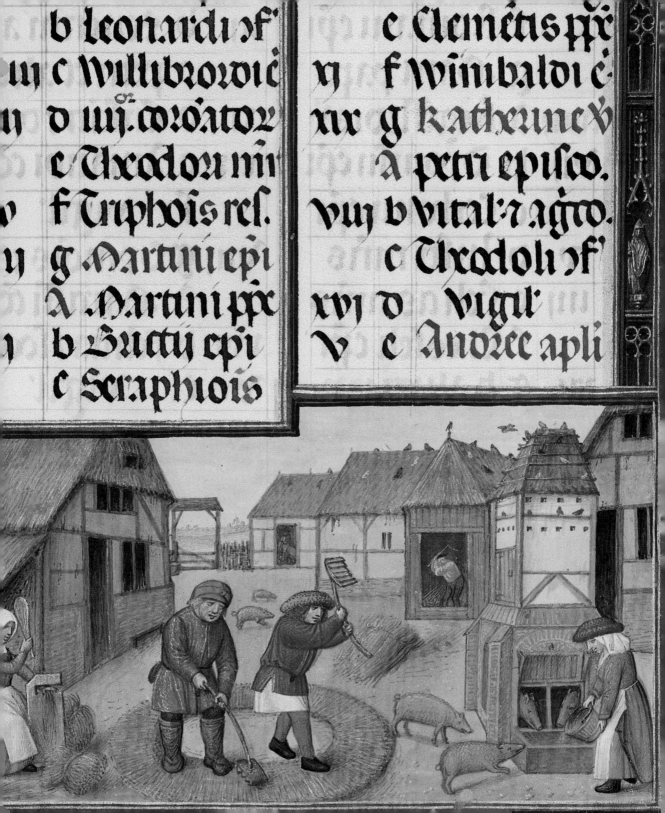

b leonardi yf'
c Willibrovic c̄
d iiij. coronator
e Treadon niī
f Triphois rcł.
g Martini epi
A Martini ppē
b Bricti epi
c Seraphiois

c Clemētis ppē
f Wimbaldi c̄
g katherine v̄
A petri episco.
b vital'z agco.
c Treadoli yf'
d vigił
c Andree apli

MIRROR OF THE MEDIEVAL WORLD

The buildings that formed the medieval world are fascinating structures that at times seem far removed from our own modern buildings and yet are sometimes direct ancestors of the edifices we build today. Beyond the castles and cathedrals that spark our imagination, the world of the Middle Ages was populated by a variety of structures, as attested by their presence in medieval manuscripts. The images that follow offer windows onto the facades and into the interiors of these buildings, as well as insights into their use and how they were built, making visible the medieval life that took place in, around, and in front of these structures.

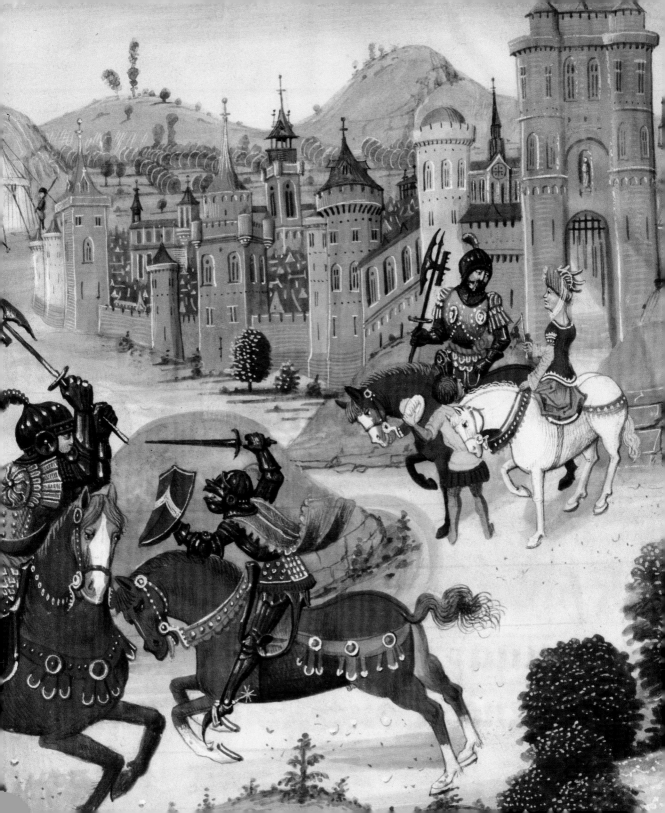

Romantic tales of damsels in distress, captured in fortified towers and saved by gallant knights who arrive to rescue them from the brutal lord of the castle, have inspired many a Hollywood movie and Halloween costume. The more sinister aspects of these majestic structures are equally enthralling. Castles have been portrayed as being accessible only by crossing a drawbridge over a murky moat and entering through a rounded archway with a menacing iron grate known as a portcullis (fig. 4). This grate could be suddenly lowered against intruders should they manage to avoid the pots of boiling hot oil poured down on their unlucky heads from the shelter of the jagged roofline. While there is a degree of fantasy in all of the above, there is also considerable truth. In the Middle Ages castles were held in high regard as strong, beautiful, and safe havens for all who dwelled within. The castle also spoke volumes about the great wealth and prestige of its noble owner and the members of his court. All of these features made castles imposing and memorable features on the medieval European landscape and in our modern mental landscape as well.

previous page:
Fig. 4
The Abduction of Ydoire
Loyset Liédet
Cutting from *History of Charles Martel*
Brussels and Bruges, 1467–72
JPGM, Ms. Ludwig XIII 6, leaf 1

Fig. 5 ◁ ▷
**Initial A: Two Men before a King
and a Man Speaking to a Family**
Feudal Customs of Aragon
Northeastern Spain, ca. 1290–1310
JPGM, Ms. Ludwig XIV 6, fol. 97

The castle incorporated into this large initial A is reminiscent of the heavily fortified structures of the high and late Middle Ages. The individual stones that form the towers are visible, revealing the sturdy, squared-off masonry of ashlar construction. The jagged roofline, so typical of castle architecture, is called crenellation. It was designed to provide both sheltered and open points through which to mount an offense and to defend against intruders. The long, narrow windows in the towers below served a similar function. Within the imposing walls of the uppermost structure in this image, a king guarded by a knight conducts his royal business, accepting visitors bearing a message written on a scroll.

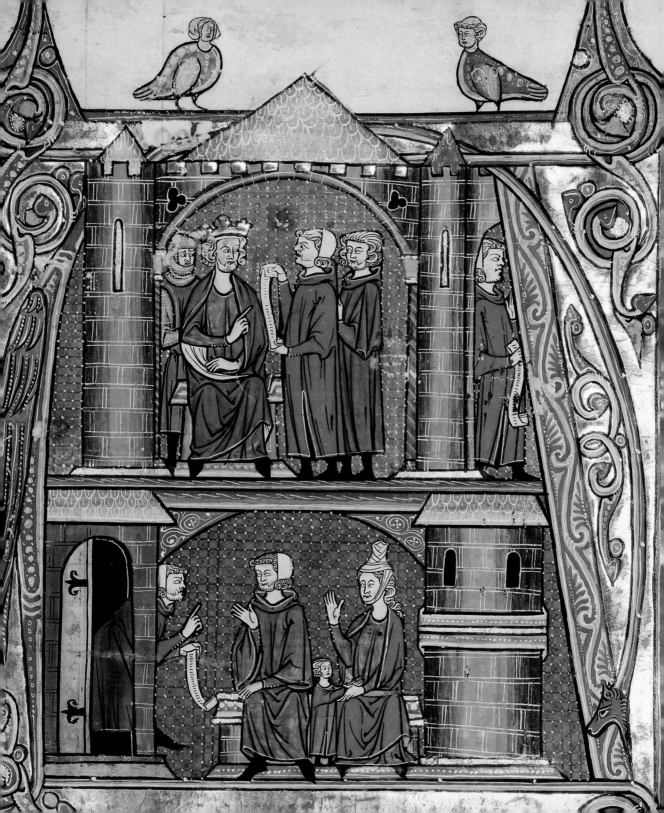

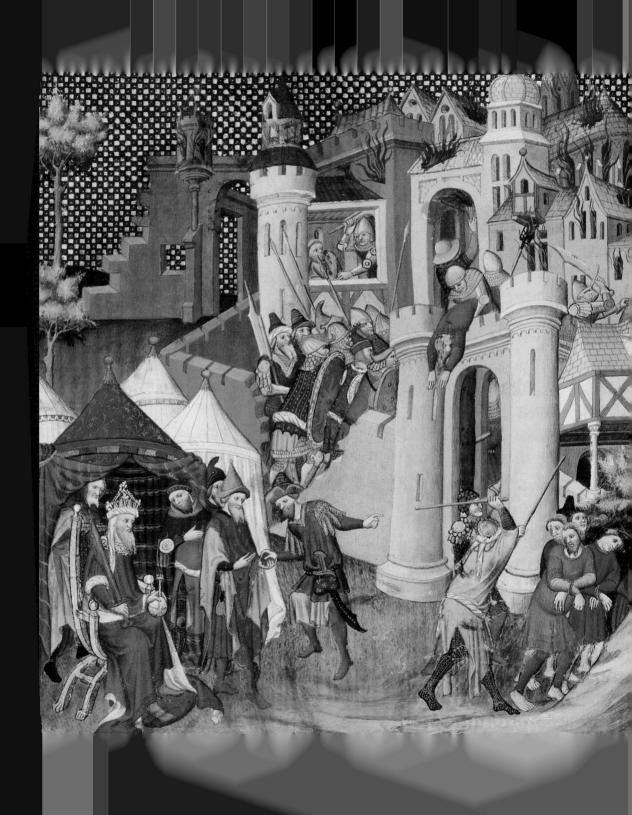

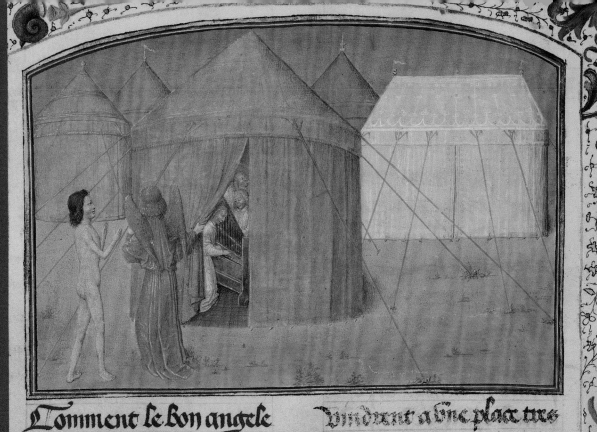

Comment le bon angele vindrent a fine place tres

Fig. 6 ◁
Walled City and Tents
[The Destruction of Jerusalem]
Giovanni Boccaccio, *Concerning the
Fates of Illustrious Men and Women*
Paris, ca. 1415
JPGM, Ms. 63, fol. 237

Fig. 7 △
Tents
[The Glory of Good Monks and Nuns]
Simon Marmion
Visions of the Knight Tondal
Ghent and Valenciennes, 1475
JPGM, Ms. 30, fol. 39v

In this image, the Roman siege of Jerusalem in A.D. 70 plays out in and around the walls of the city, depicted here as an elaborate complex of medieval buildings. The castlelike structure with two towers at the center of the metropolis provides the stage set for some of the most dramatic events. Armed Roman troops burst through the defensive wall, a soldier rushes in the door with a lit torch and the roof and windows erupt into flames, and a helmeted Roman stabs a man with a dagger. At left in the image is a second, more temporary, but no less typical form of medieval architecture—the tent. Royalty and nobles often traveled great distances with their courts, and portable fabrics fashioned into tents provided mobile living and administrative quarters during their journeys. Here, the Roman emperor Titus directs his troops in battle from the comfort of his resplendent textile hut at lower left.

CHURCH SPACES

Churches were the anchor points of the lives of medieval Christians. Because society considered churches monuments to the greatness of God, much time and energy was spent building them, and they were often the sites of architectural innovation. Some of the earliest church forms are now known as Romanesque because they were based on the building block of Roman architecture—the rounded arch (fig. 42). The central aisle, or nave, of these churches was flanked by running arcades supporting a barrel-vaulted ceiling (resembling a long tunnel). Gradually architects began to stretch the limits of these structures, building taller naves; piercing the stone walls with stained-glass windows, creating pools of colored light that dissolve the interior of the stone structure; and topping roofs with elaborate towers extending up into the heavens. The greatest height attempted in medieval church architecture was at Beauvais Cathedral in northern France. With a ceiling height of 157 1/2 feet high, it soared too high and the choir began to collapse before the building could be completed. The Gothic cathedrals built in the late Middle Ages are the ones most familiar to us today, but a wide variety of churches executed in different architectural styles appear throughout the manuscripts reproduced here.

Fig. 8 ▷
Church Interior
[Pentecost]
Master of the Dominican Effigies
Leaf from the Laudario of Sant'Agnese
Florence, ca. 1340
JPGM, Ms. 80, verso

Fifty days after Christ's ascension into heaven all of his apostles were gathered together in one place. Suddenly the Holy Spirit descended upon them like tongues of fire and gave them the ability to speak many languages so that they might go out into the world to preach Christ's teachings. Early on, medieval artists depicted this event, known as Pentecost, taking place within a church, just as the Master of the Dominican Effigies has done in this Florentine image with the Virgin Mary at the center. The French Gothic style of architecture, with its pointed arches and groin-vaulted ceilings soaring to the heavens, also appeared south of the Alps, though with particular nuances. In fourteenth-century Italian chapels, ceilings painted blue and dotted with gold stars (like that of the interior shown here) suggested the celestial focus of the liturgical ceremonies that took place in these church spaces.

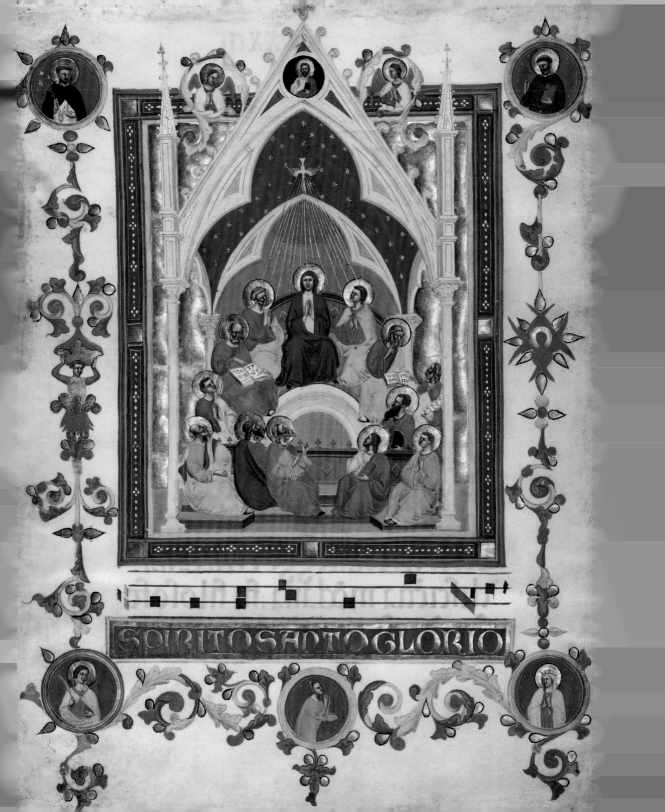

SPIRITOSANTOGLORIO

Fig. 9 ▷
Interior View of Saint-Ouen Church in Rouen
Auguste-Rosalie Bisson
Salted paper print
Rouen, 1857
JPGM, 84.XM.507.19

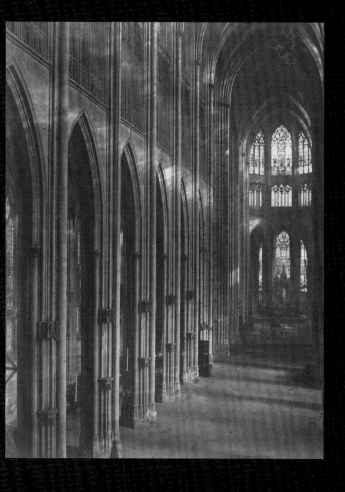

In the nineteenth century there was a revived interest in the Middle Ages—writers authored stories based on medieval narratives, painters depicted chivalric subjects and personages, and new buildings were designed using medieval architectural styles and structural elements. The invention of photography also took place during this period, and artists used this new medium to capture views of medieval buildings, especially church architecture. The similarities are striking between the nave and choir of the church of Saint-Ouen in Rouen, as it was recorded by Auguste-Rosalie Bisson in 1857, and the church choir depicted by the Master of Guillebert de Mets in the mid-fifteenth century (fig. 10)—the painted image functioning like a medieval snapshot of the artist's architectural surroundings.

Fig. 10 ▷
Gothic Church Interior
[Office of the Dead]
Master of Guillebert de Mets
Book of hours
Probably Ghent, ca. 1450–55
JPGM, Ms. 2, fol. 175v

This scene offers a glimpse of the most sacred space of a church—its choir, or sanctuary, where the high altar stands. The white archway at the foreground of the scene represents the architectural screen—often embellished with sculpture—that normally separated the sanctuary from the nave, the wide central body of the church where the lay congregation would gather for the mass. The choir was normally only accessible by the clergy—priests and deacons, and in monastic churches, monks and nuns. The ceiling of the space displays a series of rib vaults, a construction method typical of Gothic architecture that helped channel the weight of the high ceiling downward and enhanced the resonance of the hymns sung by the monks below. Close examination of the high altar within the choir reveals a miniscule gold sculpture of a female saint holding a castle tower. She may represent Saint Barbara (fig. 55) or the Virgin Mary in the guise of *ecclesia,* or the Church (fig. 60).

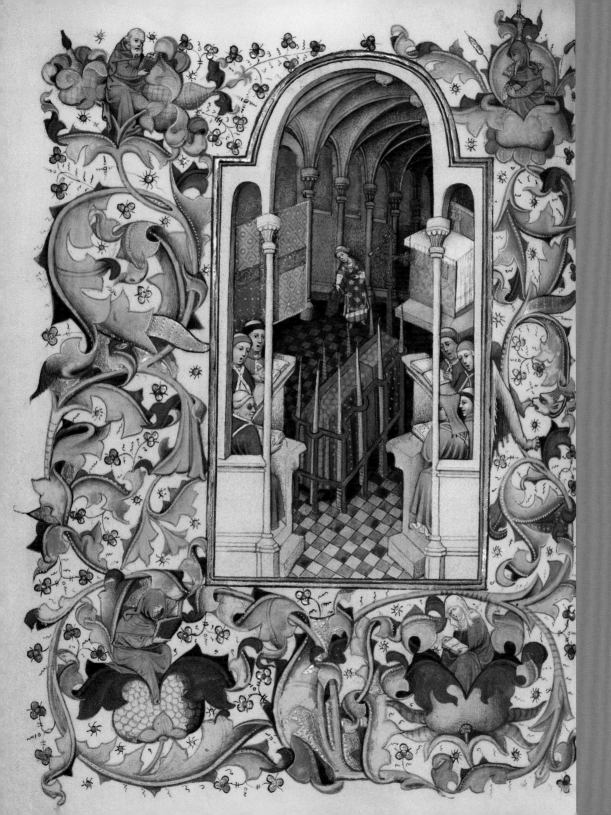

In medieval society the rooms within castle walls and the sanctuaries of cathedrals were spaces reserved for a privileged few—royalty, nobles, and the clergy. The realms of the medieval city, town, and countryside were familiar to a wider range of people. Images of these environments and their buildings often fill the pages of illuminated manuscripts, portraying a slice of medieval life. The cityscapes that form the backgrounds for biblical scenes and the calendar pages in prayer books are a rich source of information about the daily life of the middle and lower classes. These calendar pages, in addition to listing important holy days and saints' feast days, often incorporated images of the labors appropriate to each of the twelve months or of the different chores that were undertaken with the changing seasons, both in towns and in the country (figs. 3 and 14).

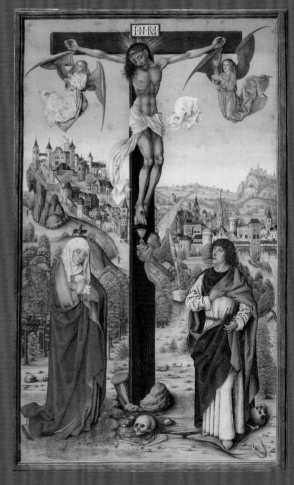

Fig. 11 ▷
Medieval German Town
[The Crucifixion]
Miniature, possibly from a manuscript
Probably Franconia, last quarter of the
15th century
JPGM, Ms. 52, recto

This powerful scene of Christ's crucifixion is set against a sweeping landscape interrupted by a sprawling medieval city. Closer examination of this metropolis reveals churches, castles, a bridge, and half-timbered dwellings—the types of structures that composed the rapidly developing European cities of the late Middle Ages. A crane moving building materials is visible above the castlelike structure at the top of the hill, suggesting this ongoing urban expansion.

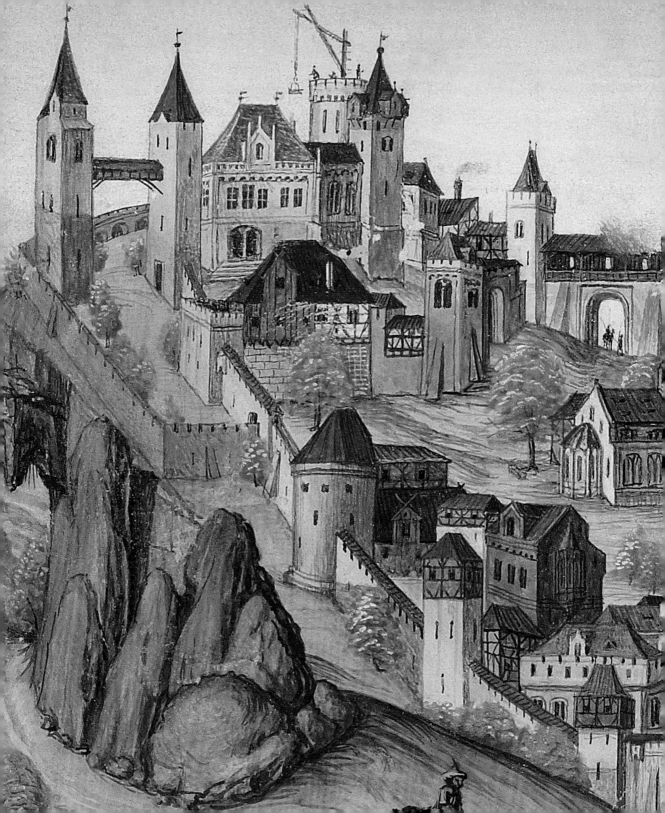

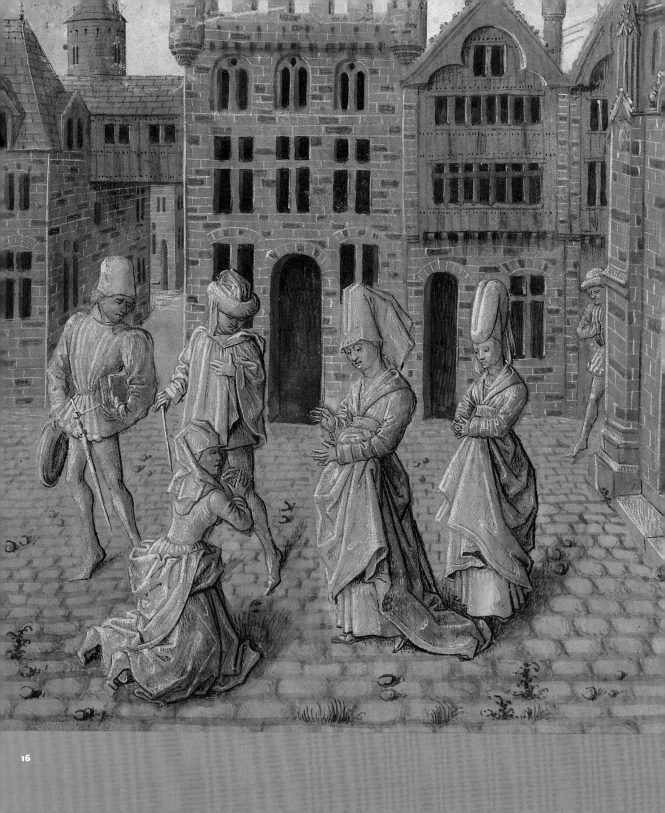

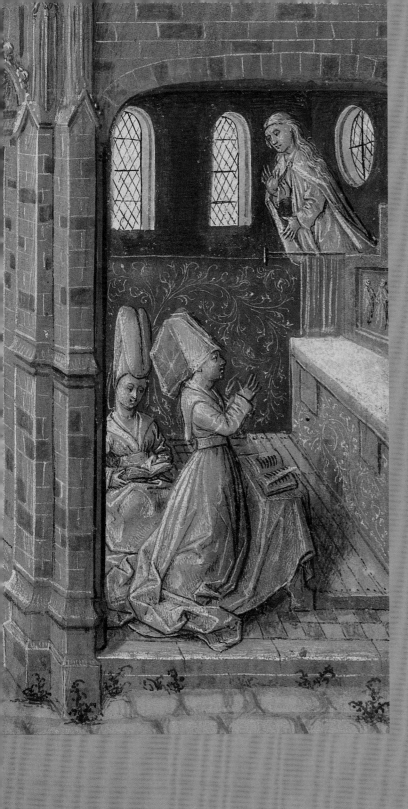

Fig. 12 ◁
Flemish Cityscape
[Miracle of the Adulterous Woman's Repentance]
Lieven van Lathem
Miniature from *Miracles of Our Lady*
Ghent, ca. 1460
JPGM, Ms. 103, recto

This miniature illustrates an account of a miracle performed by the Virgin Mary. In the chapel at right, the wife of an adulterous knight prays for the Virgin to avenge her by punishing his mistress. Because of the adulteress's devotion to Mary, the Virgin refuses the request. One day, the frustrated wife bumps into the mistress on the street, at left, and spitefully informs her that she was spared by the Virgin. The adulteress drops to her knees before the knight's wife, gratefully repents, and vows to change her ways. The artist sets this story in the streets and buildings of a typical medieval Flemish city, offering a close-up view of its three-story stone houses and church. The artist painted the scene entirely in soft shades of gray, a technique known as grisaille, as if the buildings' splendid masonry has taken over the town and transformed the men and women into stone sculptures.

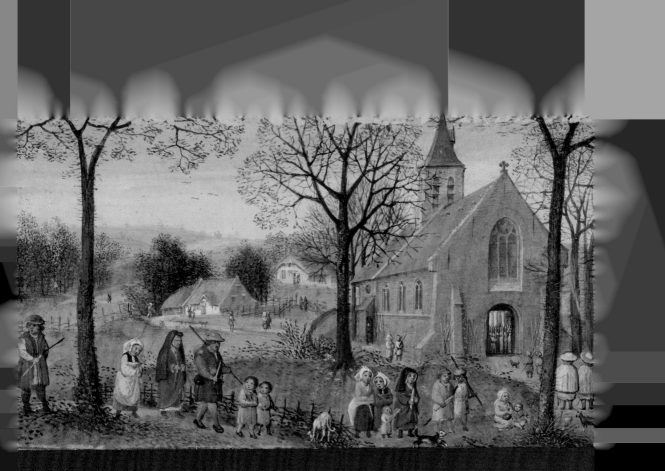

Fig. 13 ◁
Cairo
Account of a Journey from Venice to
Palestine, Mount Sinai, and Egypt
Passau (?), ca. 1467
BL, Egerton Ms. 1900, fol. 106

Fig. 14 △
Villagers on Their Way to Church
Simon Bening
Calendar miniature from a book of hours
Probably Bruges, ca. 1550
JPGM, Ms. 50, recto

This miniature once filled the lower border of the February calendar page in a Flemish book of hours. Adults and children walk toward the church holding candles in preparation for the feast of Candlemas (February 2), a day that celebrates the presentation of Christ in the temple. The scene takes place in a wide rural landscape of open hills with an out-cropping of buildings forming a small town or village. The parish church on the right dominates the complex of buildings, showing that churches were the focal point not only for individual Christians but for entire towns.

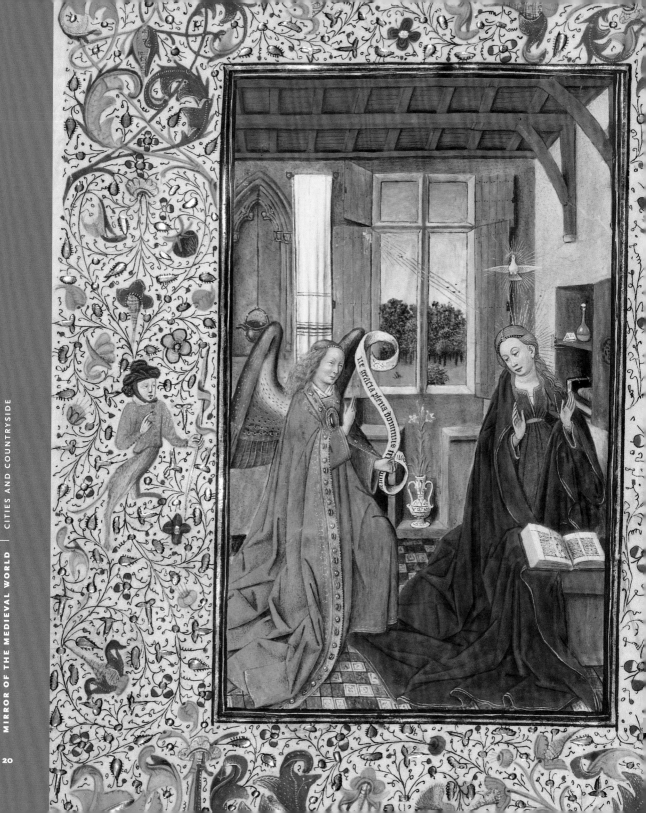

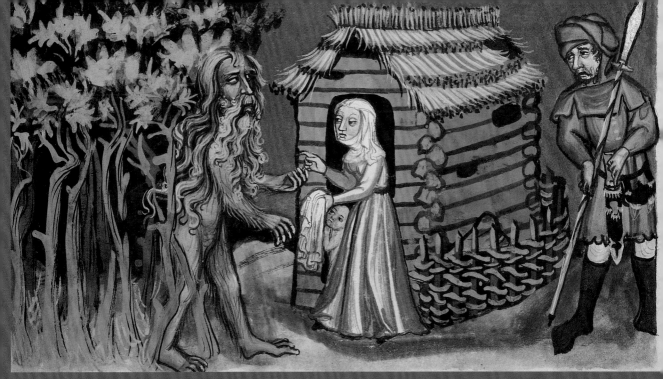

Fig. 15 ◁
Domestic interior
[The Annunciation]
Master of the Llangattock Hours
Llangattock Hours
Bruges and Ghent, 1450s
JPGM, Ms. Ludwig IX 7, fol. 53v

Fig. 16 △
A Log Cabin in the Woods
[Nebuchadnezzar Is Given Hospitality by
a Family of Charcoal Burners]
Rudolf von Ems, *World Chronicle*
Regensburg, ca. 1400–10
JPGM, Ms. 33, fol. 216

The archangel Gabriel appears to the Virgin Mary, interrupted at her reading, to tell her that she will conceive a child and name him Jesus. The biblical account of this event in the Gospel of Luke relates that it took place in Nazareth but provides no other details about where Mary was in the town nor what her surroundings looked like. Medieval artists took license to portray the event inside a well-appointed building—often a church or a domestic interior. In this Annunciation, the Master of the Llangattock Hours depicts the event in the type of home built and decorated by well-off European families in the late Middle Ages. The room features wood-beamed ceilings, double-shuttered windows, and recessed cabinets, as well as a wash basin and towel on the back wall and a lily-filled majolica vase beneath the window. This comfortable setting reflects neither the appearance of a home in Nazareth around the beginning of the first millennium nor Mary's poverty, but it would have made the event all the more relevant to the wealthy owner of the book of hours that contains this image.

Simpler structures inhabited by the lower classes of society also appear in medieval imagery. After proudly boasting about his worldly kingdom, Nebuchadnezzar, the great ruler of Babylon, is denounced by God, who tosses him out into the wilderness. This German world chronicle demonstrates the king's fall from power by depicting him naked and wild haired, forced to accept clothing from lowly charcoal burners. The family's simple dwelling is reminiscent of a log cabin, with notched wood beams fitted together to form the walls, a thatched roof, and even a woven wattle fence to mark off their property.

Manuscripts and architecture were inextricably linked in the Middle Ages. The dedication of a church, or its renovation, was an important event and was often documented in new books of prayer and music created to celebrate the occasion. Manuscripts were also a favorite venue for the depiction of buildings associated with their owners. These could be commissioned books of prayer or secular fiction with images that depict individuals reading these books in their private chapels and homes. A few manuscripts even include images of the patron's various castles and chateaux, constituting a kind of visual inventory of his or her architectural possessions. On some occasions depictions of these structures are schematic, merely suggesting the overall look of a building; in other cases they are nearly exact replicas of what particular buildings looked like at the time when their portraits were painted onto the pages of the manuscript.

Fig. 17 ▷
The Nuremberg Residence of the Derrer Family
Georg Strauch
Genealogy of the Derrer Family
Nuremberg, ca. 1626–1711
JPGM, Ms. Ludwig XIII 12, fol. 130v

Fig. 18 ▷ ▷
The Nuremberg Residence and Garden of Magdalene Pairin
JPGM, Ms. Ludwig XIII 12, fol. 130bis

These two images of imposing residences (at right) are the final two "portraits" at the end of a series of likenesses of Derrer family members in their illustrated genealogy. The massive stone construction on the left draws upon the ashlar style of castle architecture, and the residence that overlooks the lush garden of Magdalene Pairin, a space that survives today just outside the modern-day city of Nuremberg, displays the half-timbered, wood-frame construction technique commonly found in German architecture, and elsewhere in Europe, beginning in the twelfth century. This visual record of the impressive buildings they commissioned—marked clearly with identifying inscriptions above—was an effective way of preserving the reputation of the Derrer family long after the death of the family members and the later remodeling of the buildings depicted here.

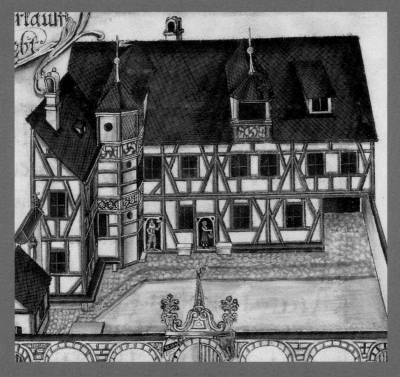

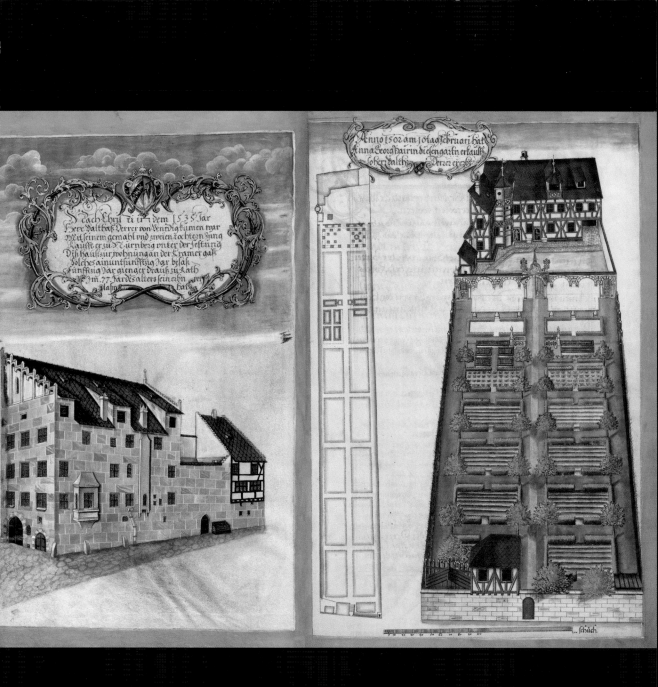

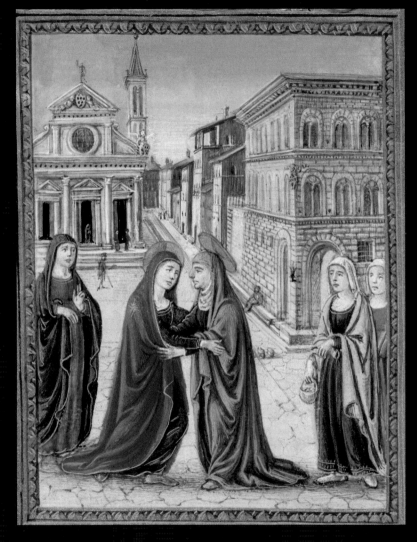

Fig. 19 ◁
The Visitation
Attavante degli Attavanti
Hours of Laudomia de' Medici
Florence, ca. 1502
BL, Yates Thompson Ms. 30, fol. 20v

The Virgin Mary and her cousin Elizabeth, pregnant with Jesus and John the Baptist respectively, embrace on a bustling street as their female companions approach from both sides. The artist Attavante added an unusual twist to this popular scene by setting it against the backdrop of a famous square in Florence, Italy. The church of San Giovannino, with its three doorways, topped by triangular pediments, and a superstructure supported by scrolls and dominated by a round central window, stands at left. On the right, across the street known as the Via Gori, is the Medici Palace, a building composed of three stories, each displaying different cuts of stone, which was completed in 1460, just decades before the creation of this manuscript. This scene presents a snapshot of life in Renaissance Florence among these architectural monuments, as a man rests on the curb next to the Medici Palace, and other individuals converse on the steps of the church. This juxtaposition of biblical figures and Renaissance buildings likely reflects the desires of the book's patron, Laudomia de' Medici, daughter of the influential Lorenzo de' Medici. Their family coat of arms appears prominently on shields that hang on the church and palace. This image is a lasting record of the sophisticated architectural patronage of her family in the book of hours she used in her daily prayers.

Fig. 20 ▷
The Presentation of a Book
Augsburg Sacramentary
Augsburg, second or third quarter of
the 11th century
BL, Harley Ms. 2908, fol. 8

The direct connection between manuscripts
and architecture is spelled out in this dedi-
cation image. A bishop, possibly Heinrich
II of Augsburg, presents a book to Ulrich,
the patron saint of Augsburg Cathedral.
The manuscript he holds represents the sac-
ramentary within which this image appears
and which would have been used by the
priest to say the mass within the very same
church depicted in this scene. While not
identifiable definitively as Augsburg Cathe-
dral, the church space shown here displays
the features commonly found in German
churches in the eleventh century, includ-
ing towers at the west end of the church (at
far left) and over the central crossing, and
elaborate hanging chandeliers, themselves
architectural in form. Setting scenes such
as this book presentation within the frame-
work of a sanctified church space was one
way early medieval artists used architec-
ture to legitimize and localize a manuscript
commission.

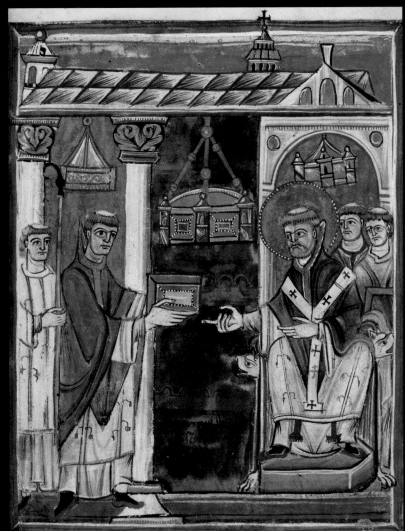

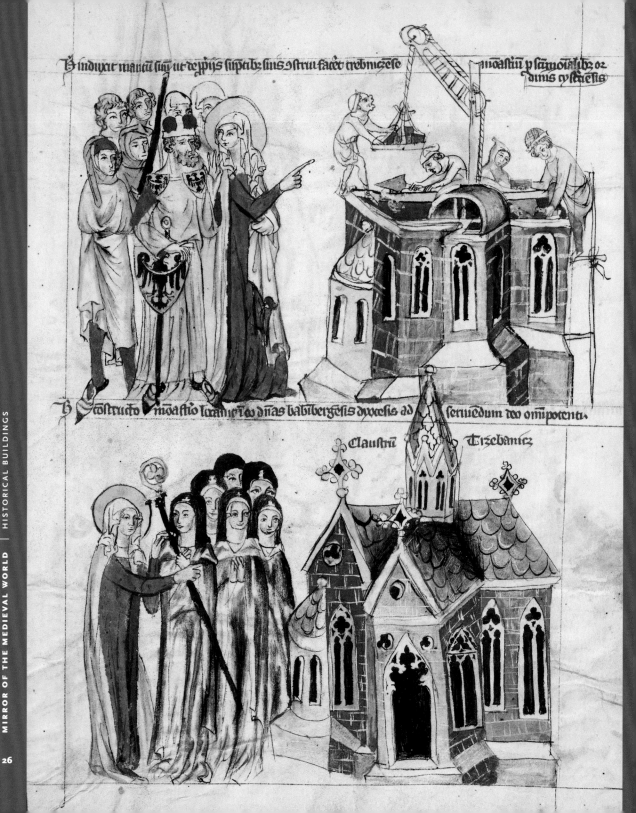

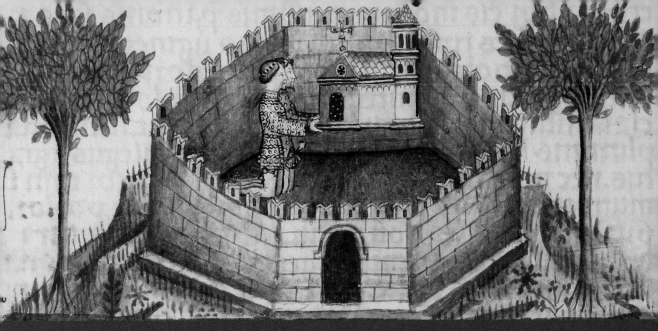

Fig. 21 ◁
**Saint Hedwig and the New Convent;
Nuns from Bamberg Settling at the
New Convent**
Court Workshop of Duke Ludwig I
of Liegnitz and Brieg
The Life of the Blessed Hedwig
Silesia, 1353
JPGM, Ms. Ludwig XI 7, fol. 56

The foundation of a new church was one
of the most common types of building
dedication recorded in medieval texts and
images. *The Life of the Blessed Hedwig*
commemorates the patron's sponsor-
ship of a new convent at Trebnitz—she is
shown directing the building project and
then ushering the new community of nuns
into the completed church. At upper left,
workers busily apply mortar and lay down
bricks, demonstrating how the medieval
world was built. The finished structure
below features tall lancet windows and
a tower topping the building where its
two arms cross, both common features of
Gothic churches.

Fig. 22 △
**Aimo and Vermondo Holding Up the
Church of Saint Victor**
Attributed to Anovelo da Imbonate
The Legend of Aimo and Vermondo
Milan, ca. 1400
JPGM, Ms. 26, fol. 4v

The Legend of Aimo and Vermondo tells the
story of two aristocratic brothers who lived
in Milan at the end of the eighth century.
After being rescued from certain death by
Saint Victor during a boar hunt, they decide
to thank their savior for his generosity by
dedicating a church in his name in the town
of Meda. In this image, Aimo and Vermondo
kneel within a crenellated wall reminiscent of
castle fortifications. They extend before them
what appears to be a model of the church of
Saint Victor in miniature. This motif was a
kind of medieval shorthand commonly found
in church dedication images, which simulta-
neously represented both the act of spon-
sorship and the appearance of the finished
church that was the result of the gift.

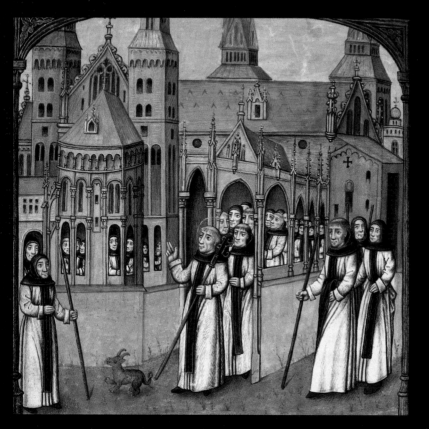

Fig. 24 ▷
**The Construction of Venice,
Sycambria, Carthage, and Rome**
Master of the Geneva Latini
Jean de Courcy, *Chronicle of the
Bouquechardière*
Rouen, ca. 1450–75
BL, Harley Ms. 4376, fol. 150

This page from a French history of the
world documents the construction of
four major cities of the Roman Empire
as their legendary founders look on.
The brightly colored and fantastical
buildings reveal the artistic license
the illuminator took in depicting this
scene. Rather than trying to re-create
the actual appearance of these places
and their architecture, he borrows
from the forms of northern European
Gothic architecture to offer eye-
catching renditions of some of the most
important cities of all time as they rise
before our eyes.

Fig. 23 △
**Saint Bernard Taking Possession of
the Abbey of Clairvaux**
Master of the Trivial Heads
Oliver de la Marche (?), *Abridged Chronicles
of the Ancient Kings and Dukes of Burgundy*
Bruges, ca. 1485–90
BL, Yates Thompson Ms. 32, fol. 9v

Saint Bernard was a major proponent of
monastic reform in the twelfth century,
and he founded the monastery of Clairvaux
according to the ideals he promoted. In
this image, Bernard arrives with a group
of monks to inhabit the new monastery,
shown here as a vast complex of buildings.
Clairvaux was built in 1115, the heyday of
Romanesque architecture in France. This
style of building, based on the forms of
ancient Roman architecture, is reflected in
the rounded arches of the window frames
and arcades on the exteriors of the various
structures. Bernard was a fierce opponent
of decoration in monasteries and their
churches because he felt it distracted monks
from their prayer. The clean lines of the
unadorned architecture shown here follow
Bernard's regulations for an ideal church.

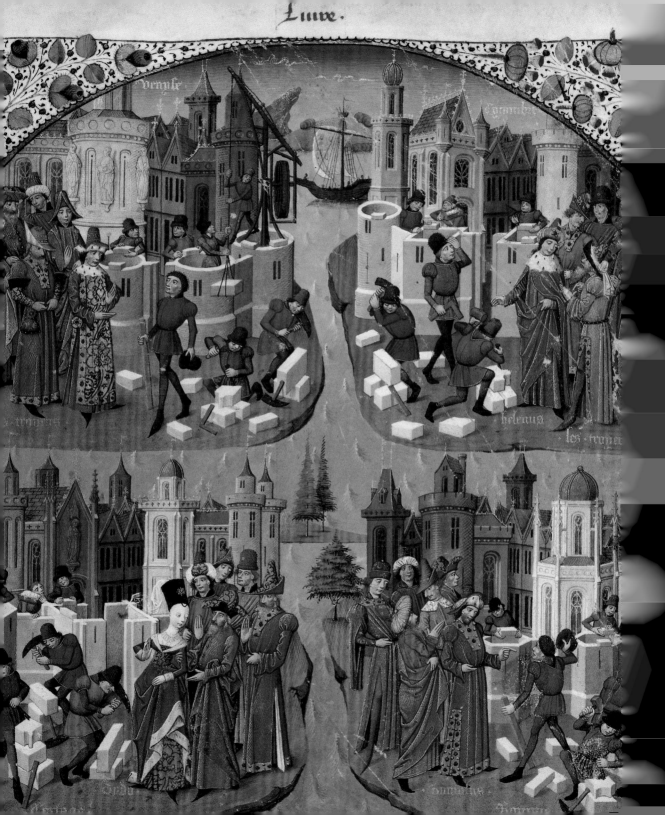

Medieval buildings fascinate the modern-day viewer not only because of their great beauty but also for the seeming impossibility of their existence. We marvel at how soaring cathedrals and vast palaces could have been built long before the invention of mechanized construction methods, power tools, and the mass production of building materials. Thanks to observant artists, the secrets of how medieval structures were built were also carefully recorded in manuscript illumination. History manuscripts often describe and depict the building of such famous cities as Venice, Rome, and Thebes (fig. 25). In biblical texts, images of the Tower of Babel being constructed (figs. 26 and 37) were the most frequent stage for the display of medieval building methods, but scenes of the rebuilding of the temple in Jerusalem also offer insights into construction (fig. 36). Some techniques and tools shown here will be familiar, while others have long become extinct as they were replaced by more modern means.

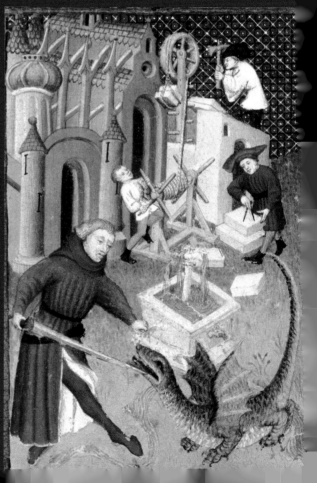

Fig. 25 ▷
The Construction of Thebes and Cadmus Killing the Dragon at Ares' Spring
Attributed to the Master of the Cité des Dames and workshop
Christine de Pizan, *Letter of Othea to Hector*
Paris, ca. 1410–14
BL, Harley Ms. 4431, fol. 109

The background of this scene of dragon slaying displays a complex of buildings in different states of construction. At far right an architect dressed in fine clothing uses a compass to measure a block of stone. The boy laborer on the ground cranks a rope laid over a pulley to hoist masonry blocks to the builder on the roof. Already complete, to the left, are a gate flanked by towers and a Gothic cathedral shored up by a row of flying buttresses. The structures suggest the architectural landscape of France around the year 1400 when this manuscript was made, rather than buildings in the Egyptian city of Thebes around 2000 B.C., when the event depicted took place.

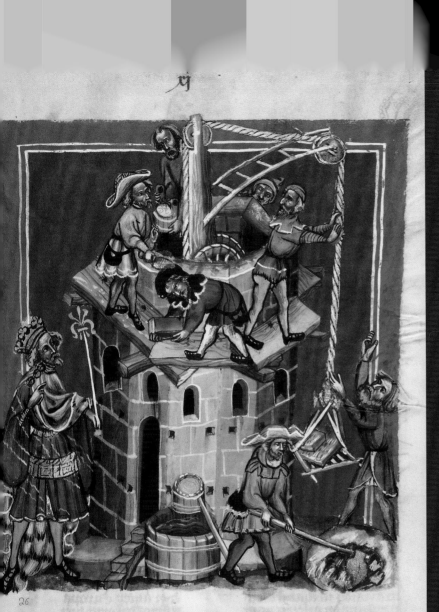

xj

t disen sollen stunden
ez werches si begunden
id hoten in der tage zil
ez werches gächs also vil
euwachet daz ez sich gezoch

ster dann funf tausent schrit hoch
vnd silenzig vn nawn hundert
vnd vier schrit auz gesundert
stit zwain vn silenzig ekken was
Der selb turn alz ich ez laz

Fig. 26 ◁
The Construction of the Tower of Babel
Rudolf von Ems, *World Chronicle*
Regensburg, ca. 1400–10
JPGM, Ms. 33, fol. 13

At left, Nimrod, king of the Babylo-
nians, oversees the construction of a
tower "that reaches to the heavens,"
which he commissioned to com-
memorate the greatness of mankind.
God punishes this human audac-
ity by causing the builders to speak
many languages so that they cannot
communicate with each other. In this
German depiction, the builders, not yet
babbling, work together in an assembly
line arrangement as they lay one row
of stones atop the next to accom-
plish Nimrod's order. The planks of a
wooden scaffold support several men
who receive additional stones hauled
upward by a pulley system. Another
worker carries the masonry to a man
with a trowel, who applies mortar from
a bucket to secure the stones to the wall
of the tower. The smaller square holes
(putt holes) visible in the stones were
anchor points for the scaffolding and
were abandoned as the construction
progressed higher.

26

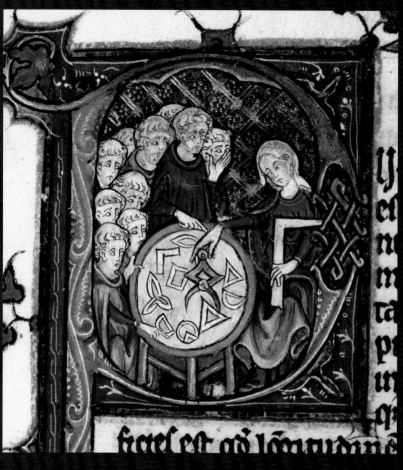

Fig. 27 △
**A Woman with a Set Square
Teaching Students**
Attributed to the Meliacin Master
Scholastic miscellany
Paris, between 1309 and 1316
BL, Burney Ms. 275, fol. 293

Fig. 28 ▷
The Construction of a Bridge
Godefroy le Batave
François du Moulin and Albert Pigghe,
Commentaries on the Gallic War
Paris or Blois, 1519
BL, Harley Ms. 6205, fol. 23

A crowd of men scramble in and out of boats as they lay the foundation for a bridge spanning the rocky cliffs flanking a river. This scene depicts the use of many of the same tools and construction techniques depicted in earlier manuscripts; however, unlike those more abbreviated and symbolic treatments of building scenes, this image reveals the vast manpower and great activity involved in the construction of architecture in the Middle Ages. It also demonstrates medieval understanding of engineering principles, such as the diagonally placed beams that stabilize the structure.

The woman on the right demonstrates an architect's tools of the trade to a group of men in scholars' dress. In her left hand she holds a set square, or T square, an instrument used to draw parallel lines, and in her right she grasps a compass. The geometric forms on the table represent the various shapes that one can draw with these devices, and they form the building blocks of Gothic stained-glass windows and traceries (fig. 70). Since female architects are thought to have been rare in the Middle Ages, she is likely an allegorical personification of geometry.

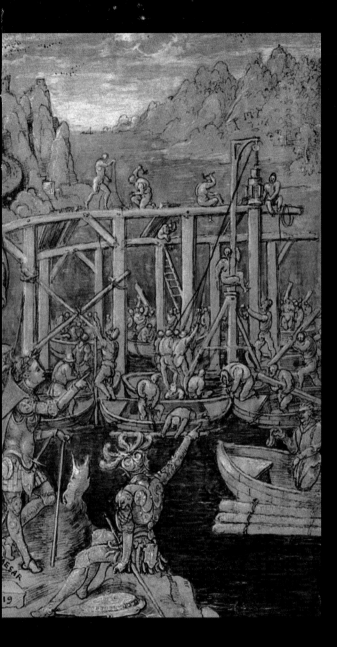

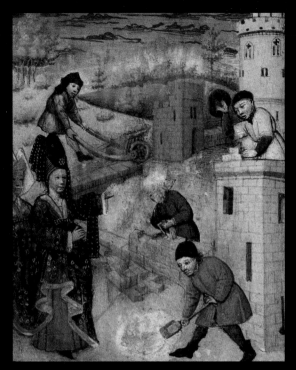

Fig. 29 △
**Mélusine Supervising the Building
of a Chateau**
Attributed to the Créquy Master
Romance of Mélusine
Amiens, ca. 1450
BL, Harley Ms. 4418, fol. 43v

Perhaps the single most important factor
in the construction of a building is not the
tools used, but the patron who initiated the
project and provided financial backing. In
this image, Mélusine, a legendary water
nymph, here dressed as a French noble-
woman, oversees the building of her chateau.
She stands at left and directs the workers:
one carries stones in a wheelbarrow, another
mixes mortar, a third applies it with a trowel
to a fortifying wall, and the man at far right
wipes his brow with exhaustion.

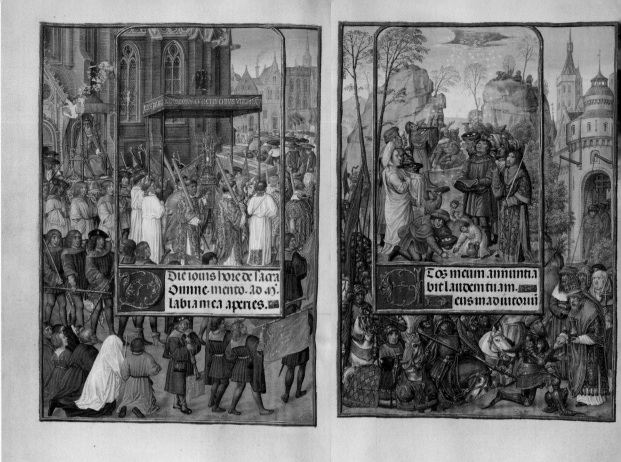

Focus: Architecture Inside and Out

Flemish artists around the year 1500 took great interest in accurately depicting the minute details of objects found in daily life and in nature. The Spinola Hours teems with biblical scenes that juxtapose stories from the Old and New Testaments, many of which by definition take place in architectural settings. The reader is presented with castles, churches, and buildings surrounding town squares, all painstakingly rendered down to their stones. Even the fine cracks in a castle gate (fig. 32), and the yellow mineral deposits left on the stone facades of buildings by rainwater (figs. 33 and 35) are recorded. In addition to these more typical views of architecture, the artist sometimes sliced away the front wall of these buildings, offering voyeuristic vistas into their interiors. These innovative, cross-sectional views allow careful examination of sacred and secular buildings from outside and within, as figures in the margins pass through their doors from exterior facade to interior space.

Spinola Hours
Bruges and Ghent, ca. 1510–20
JPGM, Ms. Ludwig IX 18

Fig. 30 ◁ ◁
Church Facade
[Procession for Corpus Christi]
Master of James IV of Scotland
fol. 48v

Fig. 31 ◁
Castle
[The Israelites Collecting Manna
from Heaven]
Master of James IV of Scotland
fol. 49

The images on these two facing pages are
linked in several ways. The procession
of figures in the Corpus Christi scene
marches to the right, giving the illusion
of blending into the stream of soldiers
who enter from the lower left corner of
the facing scene of the Israelites collecting
manna, or food from heaven. The outer
walls of a cathedral in a medieval city
frame the procession, and the tall, round
tower of a castle anchors the composition
on the opposite page. This visual linkage
of sacred and secular architecture also
helps connect the stories displayed on the
facing pages. Both deal with the idea of
sacred food—on the left the veneration of
Communion bread representing the body
of Christ for the spiritual nourishment
of Christians, and on the right, food sent
from God to feed the Israelites.

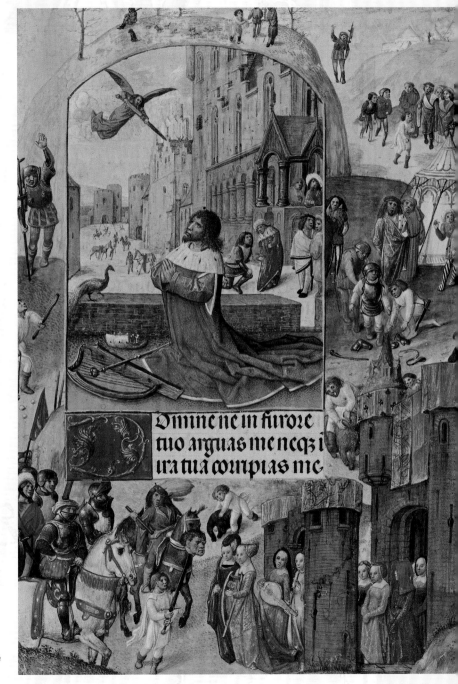

Fig. 32 ▷
Castle and Townscape
[David in Prayer]
Master of the Lübeck Bible
fol. 166

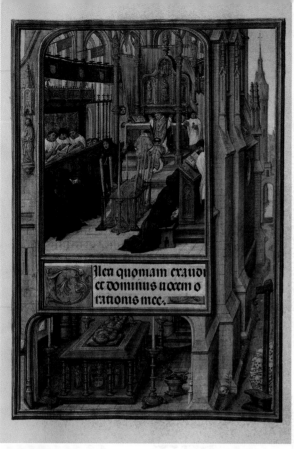

Fig. 33 △
Cross-Section of a Church
[Office of the Dead]
Master of James IV of Scotland
fol. 185

The majesty of Gothic church architecture is featured in this image of a funeral mass being celebrated inside a monumental cathedral. The oblique view along the flank of the building reveals massive stone piers that jut out from the exterior wall and allow the high-vaulted structure to soar to the heavens. The cutaway view of the church permits visual access to two normally restricted spaces: the church sanctuary, where the Mass for the Dead is taking place, and the crypt below the choir, where only very privileged individuals could be buried.

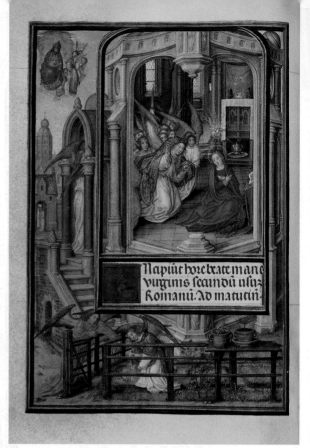

Fig. 34 △
Living Room
[The Annunciation]
Master of James IV of Scotland
fol. 92v

The framing of this scene with white marble columns and an archway initially suggests a church space, but the area in which Mary kneels to receive the archangel Gabriel and his choir of angels, who slip into the room through the door, is typical of a living room found in a wealthy Flemish household, with a tiled floor, a hearth, and a mantel. Medieval artists commonly set Annunciation scenes in the interior of a home or a church, and this image merges both of those conventions. This indicates the central place of both domestic and religious life for medieval people.

Fig. 35 ▷
Dining Room
[The Feast of Dives]
Master of James IV of Scotland
fol. 21v

Displayed inside and out of this monu-
mental stone building is the biblical
parable of the rich man Dives who
refuses to give the sore-covered Lazarus
scraps from his dinner table. The defen-
sive architectural elements echo the
poor man's predicament: he stands on a
drawbridge lowered across a moat, but
he is forbidden by Dives from passing
across the threshold of the thick-walled
castle. Through the opened front wall
of the structure we gain a broad view of
the well-fed Dives seated at a banquet
table before a cloth of honor. This scene
offers a glimpse of the type of richly
decorated dining room often hidden
from view behind castle walls. Denied
the privileged sanctuary and nourish-
ment within the lavish house, Lazarus
dies on the hillside in the foreground,
and angels lift his soul up to heaven
to receive a greater reward than Dives
could give.

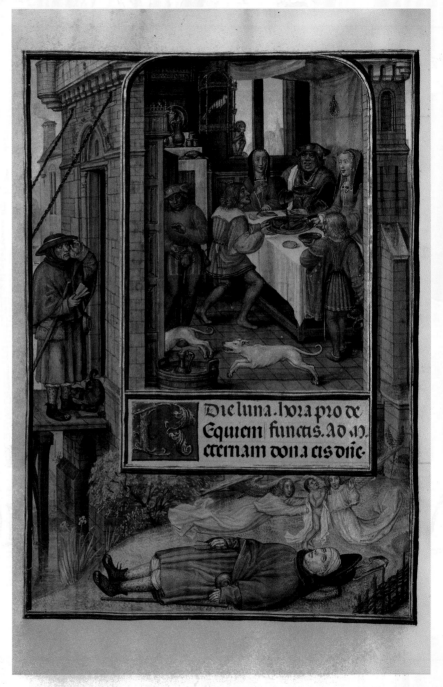

ARCHITECTURE IN STORIES AND SYMBOLS

Medieval artists' great interest in architecture was not solely inspired by a desire to record the world around them. They also understood the power of a building to portray and create stories. In contrast to the often accurate recording of the exact appearance or overall look of medieval buildings illustrated in the previous chapter, sometimes medieval artists took creative license in depicting architecture, manipulating the forms of buildings to enhance the story being told. The flexible nature of architecture as it was illustrated in manuscripts landed it a supporting or even starring role in a wide variety of stories about biblical kings, gallant knights, powerful women, and Christian saints and sinners.

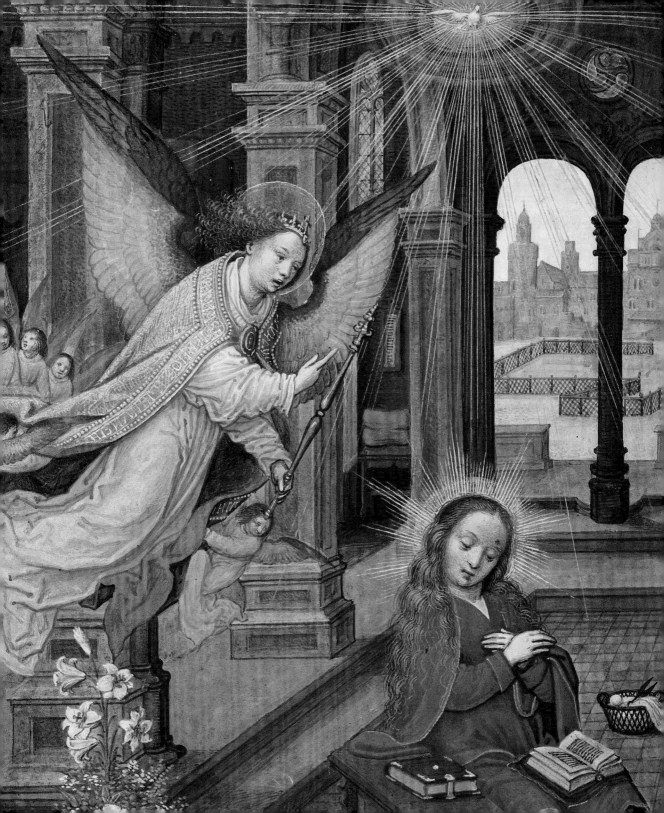

Many of the manuscripts that survive from the Middle Ages contain texts drawn from the Old and New Testaments of the Christian Bible, which were read and sung during church services and in secular homes during private prayer. Architecture was a frequent setting for biblical stories, but in some cases buildings were themselves key characters in the story. Illustrations of these texts provide some of the most intriguing insights into the medieval understanding of architecture. We see both abstracted forms of buildings that could never exist (fig. 45) and hyperrealistic renditions reflecting the architecture of the time and place in which the manuscript was made (fig. 44). Scenes drawn from scripture offer some of the best visual examples of architecture, because the structures were painted to accompany, embellish, and honor the Word of God.

Fig. 36 ▷
Initial *I*: The Rebuilding of the Temple
Marquette Bible
Lille, ca. 1270
JPGM, Ms. Ludwig I 8, vol. 3, fol. 256v

The illuminator of this manuscript expanded the form of the initial I to contain a complex scene of the rebuilding of the temple in Jerusalem. The original temple was destroyed by the Babylonians, and the text from the book of Ezra on this page describes its reconstruction under Cyrus of Persia beginning in 537 B.C. Workers climb through the structure within this letter holding a trowel and a pick, and at the top an elegantly dressed man stands holding a carpenter's square, or T square, indicating his role as the architect.

previous page:
Detail of *The Annunciation* (fig. 61)

Fig. 37 ▷ ▷
Nimrod and the Construction of the Tower of Babel
Master of the Geneva Latini
Jean de Courcy, *Chronicle of the Bouquechardière*
Rouen, ca. 1450–75
BL, Harley Ms. 4376, fol. 206v

One of the most famous structures described in the Bible is the Tower of Babel, a structure meant to reach to the heavens to attest to the greatness of man. On the right, the workers set about constructing this massive tower, which when completed, will be taller and more majestic than the fantastical and delicately rendered buildings and towers representing the city of Babylon on the left. Unlike other images of the Tower of Babel (fig. 26), this version of the scene focuses less on depicting the builders' tools and techniques than on their confusion as their progress is halted by the appearance of God and his angel messenger, who cause them to speak in many different languages so that they cannot understand each other and must stop their audacious project.

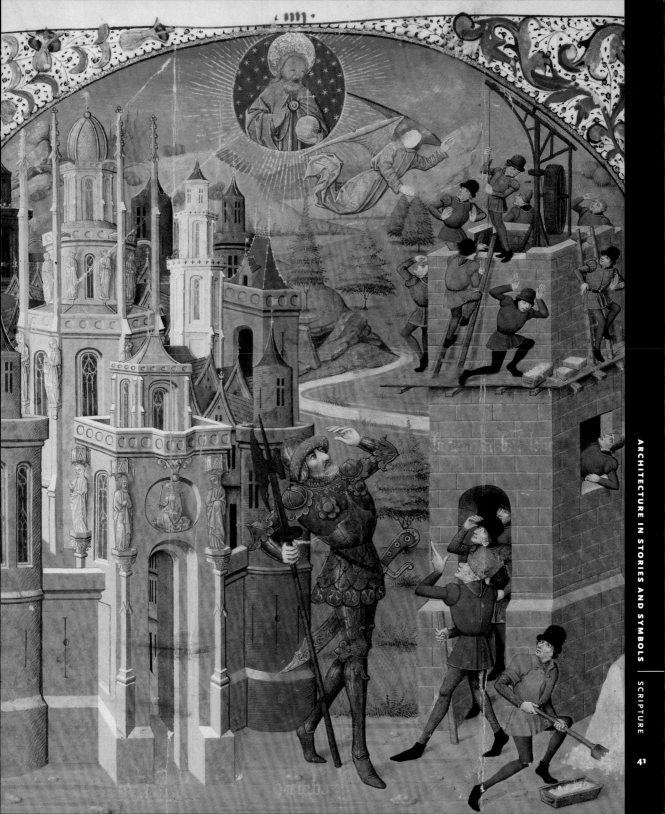

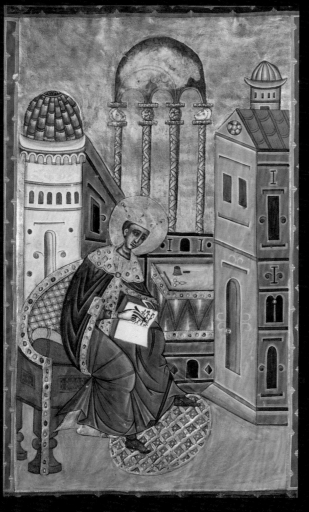

Fig. 39 ▽
Samson Holding a Column
Maastricht Hours
Liège, first quarter of the 14th century
BL, Stowe Ms. 17, fol. 122v

Samson, as described in the book of
Judges, was renowned for his superhu-
man strength and fought numerous
battles with the Philistines. Thanks to the
efforts of Delilah, who cuts his hair and
puts him in God's disfavor, he is captured
and blinded. As the Philistines gather
for a religious sacrifice, Samson asks if
he may lean against the central pillars of
their temple to rest. This book of hours
contains a marginal scene that may depict
an abbreviated version of Samson's story.
Here the long-haired hero embraces the
supporting column of a castlelike struc-
ture. The frightened faces of the building's
inhabitants peering through the windows
suggest that this is the moment before
Samson will trick them and pull the
building down by brute force and destroy
himself and the other people inside it.

Fig. 38 △
Solomon Writing
Malnazar
Bible
Isfahan, 1637–38
JPGM, Ms. Ludwig I 14, fol. 358v

King Solomon is perhaps the biblical
figure most frequently associated with
architecture. He was credited with con-
structing the first temple in Jerusalem
(to house the Ark of the Covenant) and
developing that small city into a king-
dom. Famed for his wisdom, Solomon
is shown here in the act of writing and
surrounded by a variety of buildings
that suggest the expansive empire he
built up. The two domed structures, in
particular, recall the early architecture
constructed in the cities of the eastern
Mediterranean.

Aue maria. Cũ quo tu mater ĩ egiptũ fugith. et
poſt ſeptennĩ ſeñi ad pñã redith. Alleluya
·II·

Fig. 40 △
The Flight into Egypt
Illustrated *Life of Christ* with devotional
supplements
Northern England and East Anglia,
ca. 1190–1200 and ca. 1480–90
JPGM, Ms. 101, fol. 44v

Fig. 41 ◁
Egypt; The Fall of Pagan Idols
JPGM, Ms. 101, fol. 45

Having been told of Jesus' birth and his
destiny to become the messiah, King
Herod issued an order for all the male
infants in Bethlehem to be slain. Hoping
to protect their son from certain death,
Mary and Joseph fled to Egypt. Medieval
writers associated this event with another
biblical passage that states that the Lord
will enter into Egypt and the pagan
idols will topple. This dramatic series of

events plays out across the entire span
of a double-page spread in the English
Romanesque manuscript shown here.
At left, the confidently striding donkey
brings Jesus and his family ever closer to
Egypt, depicted on the facing page as an
imposing castle. Their approach causes
immediate tumult, as the nude idols take
the plunge headfirst, still stuck by their
feet to their columns.

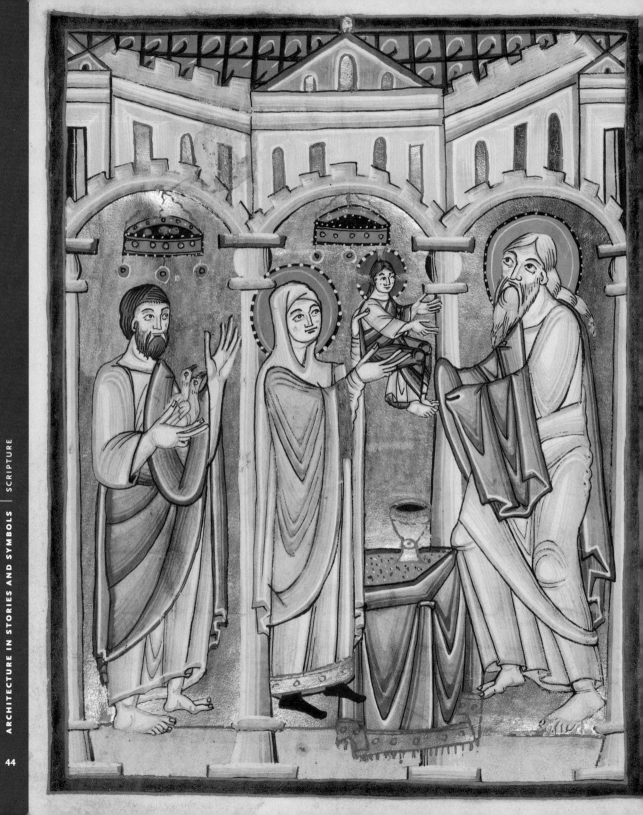

Fig. 42 ◁
The Presentation in the Temple
Benedictional
Regensburg, ca. 1030–40
JPGM, Ms. Ludwig VII 1, fol. 28

In accordance with Jewish law, forty days
after his birth, Mary and Joseph brought
Jesus to the temple in Jerusalem and pre-
sented him to the rabbi Simeon. The Vir-
gin, holding the Christ child aloft, stands
at the center of the nearly symmetrical
building depicted here. The rhythmic suc-
cession of three rounded arches supports
a substantial architectural structure remi-
niscent of the early Romanesque churches
common in Germany around the time this
manuscript was made.

Fig. 43 ▷
The Women at the Tomb
Sacramentary
Mainz or Fulda, ca. 1025–50
JPGM, Ms. Ludwig V 2, fol. 19v

Two women named Mary appear at Christ's
tomb after his death to anoint his body,
only to encounter an angel who informs
them that Jesus is no longer there. Christ's
bodiless burial shroud floating in the
tomb's entrance attests to the angel's
statement. Although the biblical account
describes Christ's burial place as a monu-
ment carved from rock, this image depicts
the tomb as a domed structure with a red,
clay-tiled roof surmounted by a cupola.
The shape of this building recalls the
Church of the Holy Sepulchre in Jerusalem,
which was built by order of the emperor
Constantine in the fourth century on the
site where Jesus was buried .

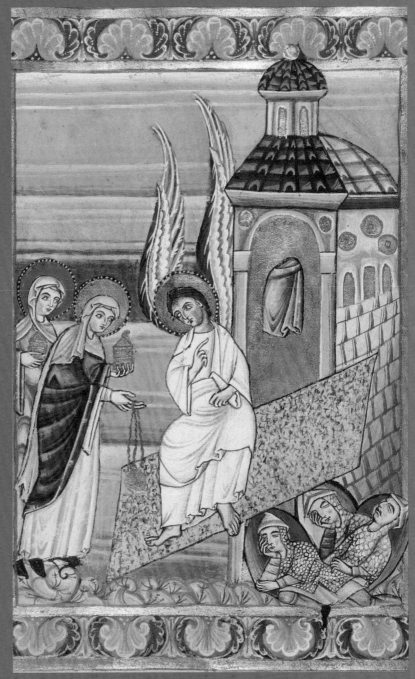

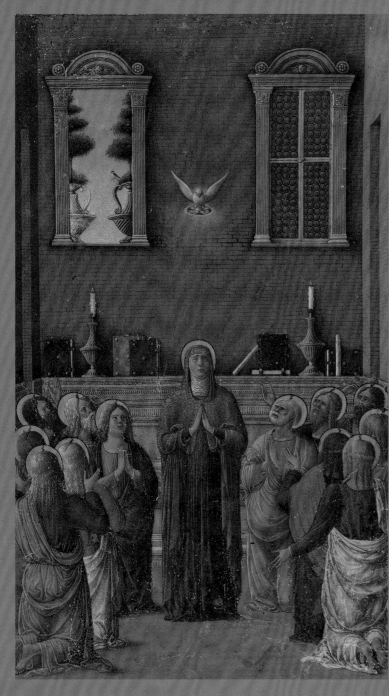

Fig. 44 ◁
Pentecost
Girolamo da Cremona
Miniature from a devotional or liturgical
manuscript
Probably Mantua, ca. 1460–70
JPGM, Ms. 55, recto

Although the biblical account of Pentecost says
only that the apostles were all "together in one
place," by the fifteenth century the convention of
depicting the event taking place within a church
was well established (fig. 8). Here, the apostles
kneel around the standing figure of Mary as the
dove of the Holy Spirit descends upon them, giv-
ing them the gift of tongues so that they might
spread the Word of God to all corners of the
earth. The striking setting, with its wide altar,
red brick walls, and windows framed with classi-
cal pilasters, recalls the forms of Italian Renais-
sance architecture. The shallowness of the space
suggests the interior of a private chapel, which
wealthy patrons often sponsored in Renaissance
churches.

Fig. 45 ▷
The Heavenly Jerusalem
Silos Apocalypse
Northern Spain, ca. 1100
BL, Additional Ms. 11695, fol. 208v

The monasteries of medieval Spain produced
numerous elaborately illuminated copies of
Beatus of Liébana's commentary on the book
of Revelation, also called the Apocalypse.
The Apocalypse describes in minute detail
the appearance of a new Jerusalem in heaven,
including its dimensions and the types of
gemstones that decorated it. This manuscript
provides a view of the city from above, flattening
the walls so that the three gates on each side are
visible. The bold colors of this image suggest the
multicolored gems that adorn the structure's
walls and gates, and they enhance the dramatic,
otherworldly mood of the biblical passage.

Fig. 46 ▷
The Seven Churches of Asia Minor
Dyson Perrins Apocalypse
Probably London, ca. 1255–60
JPGM, Ms. Ludwig III 1, fol. 2v

In a miniature that depicts the seven churches of Asia Minor described in the Apocalypse, the buildings are compressed into a single frame, like attached row houses or condominiums rather than individual structures spread out across seven different locations in what is now Turkey. The diverse types of architecture presented signify the different cultures and the particular problems and concerns of each individual church as God admonishes them one by one in the first chapters of the Apocalypse.

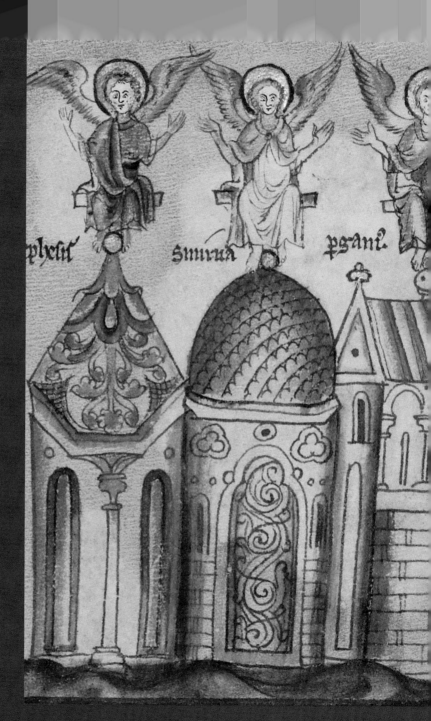

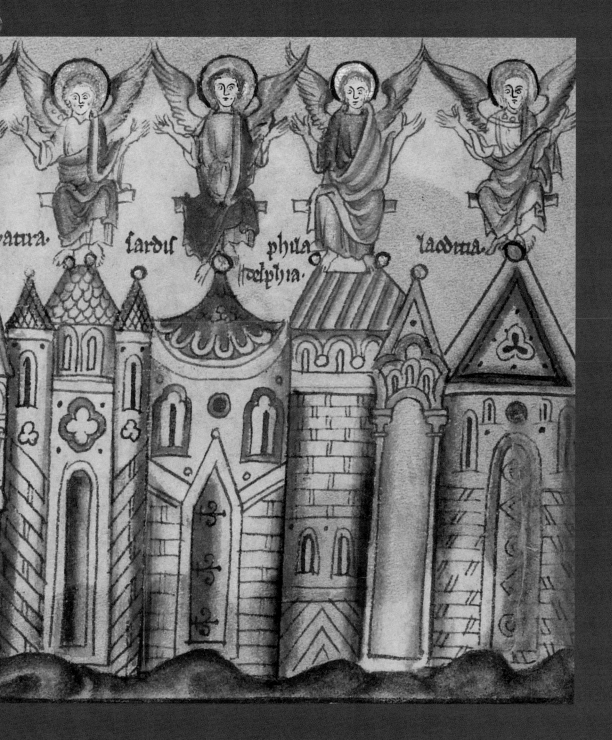

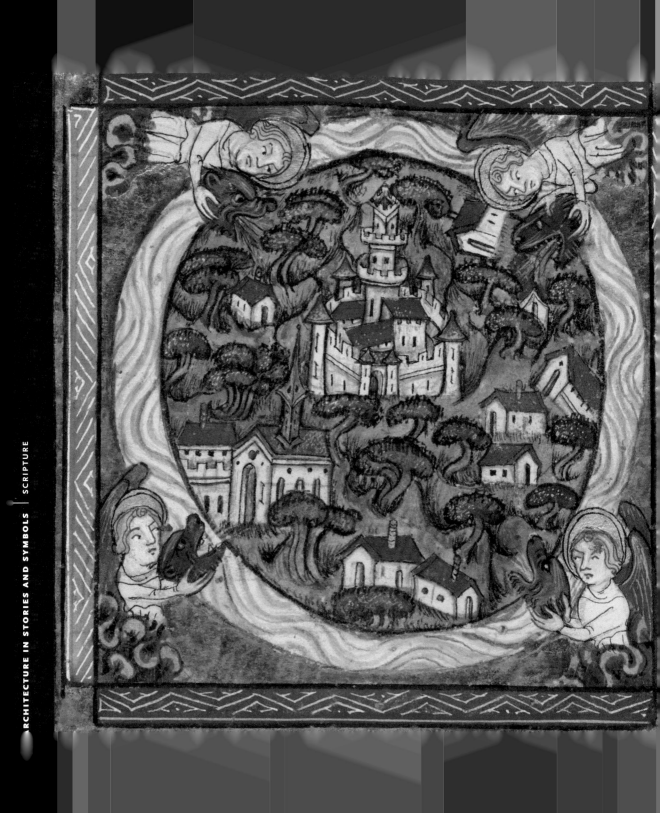

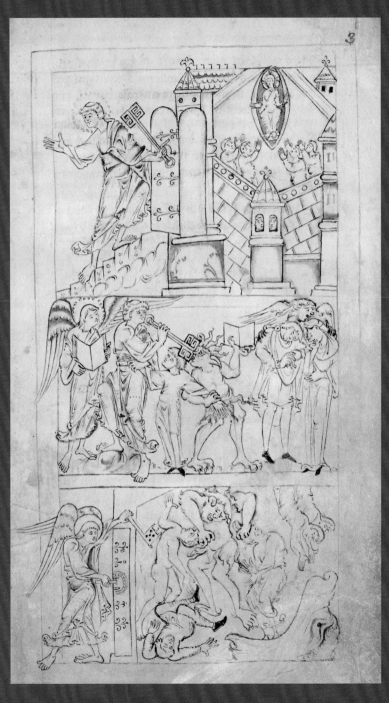

Fig. 47 ◁
Angels Holding the Four Winds
Apocalypse
Paris, ca. 1370–90
BL, Yates Thompson Ms. 10, fol. 11v

In one of the apocalyptic events described in the book of Revelation, four angels stand at the four corners of the earth holding back the four winds so that they will not blow upon the earth and destroy it. At each corner of this image, angels restrain the heads of beasts that symbolize these four winds. The artist represents the threatened world as a group of buildings fashioned like a medieval town, with an impressive castle at the center, a church with a steeple, and many smaller houses with chimneys. The angel at the upper right appears unsuccessful at his task, as the beast seems to have huffed and puffed and blown one of the houses down.

Fig. 48 ▷
Saint Peter at the Gates of Heaven
[Last Judgment]
Chronicles of the Abbeys of Newminster and Hyde
Winchester, ca. 1031
BL, Stowe Ms. 944, fol. 7

The idea of Saint Peter guarding the "pearly gates" of heaven is also based on the description of the jeweled heavenly city of Jerusalem in the book of Revelation. At the top of this delicately drawn Anglo-Saxon image of the Last Judgment, Saint Peter holds open a medieval-style door with iron fittings, allowing access to heaven, which is shown here with the fortified stone walls and towers of a medieval castle.

In the Middle Ages an individual's summer reading list was not limited to biblical texts. Romances and histories were best sellers among the wealthy, literate members of medieval society, and even monks and nuns copied and read works of philosophy and religiously themed fiction. Many of these texts were composed in the Middle Ages and closely reflected the contemporary experiences of their readers, thus it was appropriate that the buildings that populated medieval cities and the countryside should crop up in literature.

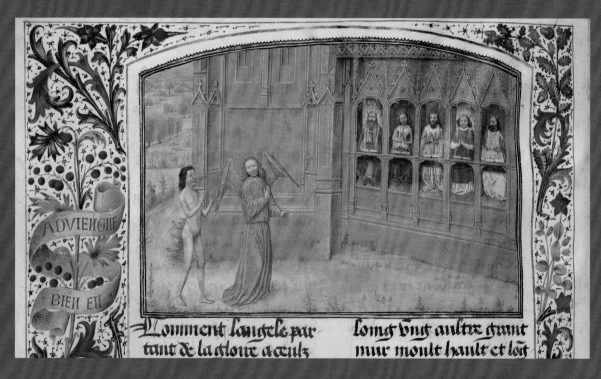

Fig. 49 △
Martyrs Enshrined in a Wall of Gold
[The Glory of Martyrs and the Pure]
Simon Marmion
Visions of the Knight Tondal
Ghent and Valenciennes, 1475
JPGM, Ms. 30, fol. 38v

The *Visions of the Knight Tondal* tells the story of a wealthy and debauched Irish knight, whose soul is guided on a journey through hell and heaven by an angel. To encourage him to correct the errors of his ways, the angel shows Tondal the fates of various types of people. Martyrs who died for their faith and individuals with pure souls are shown in this scene, sitting on thrones and enshrined in niches in the golden wall of a churchlike structure. The idea that being trapped on the facade of a building for all eternity was a great reward indicates the powerful association of church architecture with heaven itself in the Middle Ages.

Fig. 56

Ladies Building Their City

Attributed to the Master of the
Cité des Dames and Workshop
Christine de Pizan, *Book of the
City of Ladies*
Paris, ca. 1410–14
BL, Harley Ms. 4431, fol. 290

This miniature introduces the first chapter of the *Book of the City of Ladies*, the most famous work by the writer Christine de Pizan, one of the earliest known female authors. Her book reflects on great women of the past and envisions a world where women are respected. Christine herself may have been responsible for writing out this copy of her text, and she appears in this image inside her study discussing the subject of women with the allegorical figures of Rectitude, Reason, and Justice. The artist interprets the idea of the city of ladies as a walled medieval town, outside of which two noblewomen literally build the city, stacking stones and fixing them with mortar in a construction method consistent with that shown in other contemporary manuscripts (figs. 25 and 29).

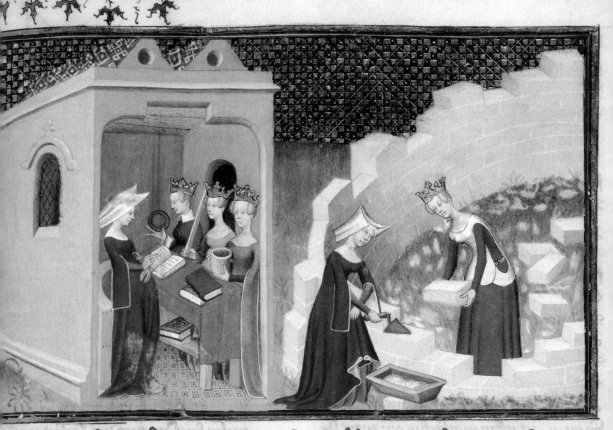

commence le liure de la Cite des Dames du quel le premier chapitre parle pour
oy et par quel mouuement le dit liure fu fait.

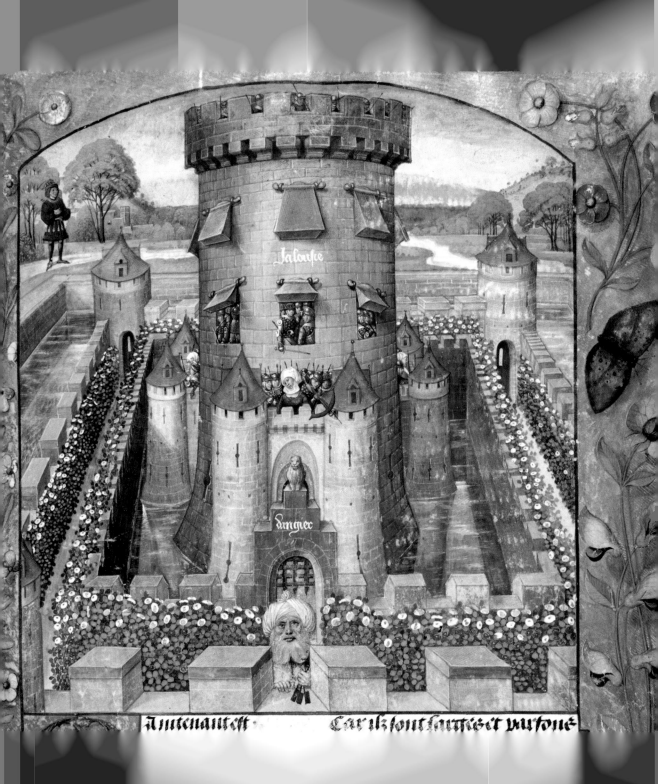

Fig. 51 ◁

The Castle of Jealousy
[The Lover Outside the Castle of Jealousy
Where Fair Welcome Is Imprisoned]
Master of the Prayer Books of ca. 1500
Guillaume de Lorris and Jean de Meun,
Romance of the Rose
Bruges, ca. 1490–1500
BL, Harley Ms. 4425, fol. 39

The *Romance of the Rose* was a popular
medieval tale that tells the story of a lover
who dreams of a beautiful rose held captive
in a castle. In this allegorical treatment of
architecture, the rose represents a woman,
and the massive castle symbolizes jealousy.
This bird's-eye view of the castle of jealousy
reveals a hyperfortified structure filled
to the gills with armed soldiers, with a
portcullis labeled "danger," two moats, and
three layers of thick, sometimes crenellated
walls. This daunting architecture suggests
that the lover, standing beyond the outer-
most wall in the upper left corner, has little
chance at penetrating jealousy's defenses to
capture the rose.

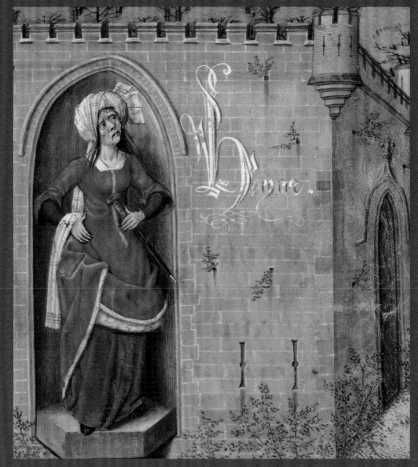

Fig. 52 △
Allegorical Figure of Hatred
Master of the Prayer Books of ca. 1500
Guillaume de Lorris and Jean de Meun,
Romance of the Rose
Bruges, ca. 1490–1500
BL, Harley Ms. 4425, fol. 8

At the beginning of the *Romance of the
Rose*, the author describes various ways in
which women behave badly. The illumina-
tor of this copy of the text portrays each
shortcoming as a woman set within a niche
in a crenellated wall of the Garden of Love.
The first of these, the figure of Haine, or
Hatred, stands with her hand at the ready
on her sword hilt, yet she is trapped within
an imposing medieval fortification. Next
to her on the wall, her name is written
prominently like a public condemnation of
her vice.

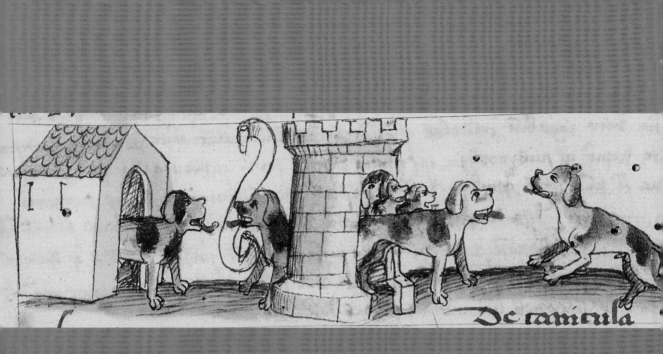

De canicula

ARCHITECTURE IN STORIES AND SYMBOLS | LITERATURE

Fig. 53 △
Dog Houses
[Two Dogs Barking and Cubs]
Aesop, *Fables*
Probably Trier, second half of the 15th century
JPGM, Ms. Ludwig XV 1, fol. 3v

The fable depicted here tells a moralizing
story of trickery. A dog who was ready
to give birth to puppies asks a shepherd
to give her a place to litter. At left, the
shepherd, shown here as another dog,
honors her request and provides her
with a doghouse. When the puppies are
grown, however, they are strong enough
to defend their house, which has similarly
transformed into a sturdy castle tower.
Now threatened by the mother and her
pups, the shepherd dog rears back in fear
and can no longer approach the spot he
generously gave.

Fig. 54 ▷
**An Elephant Carrying a Tower Filled
with Soldiers**
*Account of a Journey from Venice to Palestine,
Mount Sinai, and Egypt*
Passau (?), ca. 1467
BL, Egerton Ms. 1900, fol. 110

In the mid-fourteenth century, the Fran-
ciscan friar Niccolò da Poggibonsi made
a pilgrimage to the Holy Land and wrote
an account in Italian of all the cities he
saw (fig. 13) and the fantastic creatures he
encountered. This manuscript, a German
translation of Poggibonsi's text, describes
the mighty elephant that is able to carry
a wooden tower filled with thirty men
on its back. The artist has portrayed this
architecture-on-the-move as a crenel-
lated structure plucked straight out of a
medieval castle and filled to the brim with
armed soldiers.

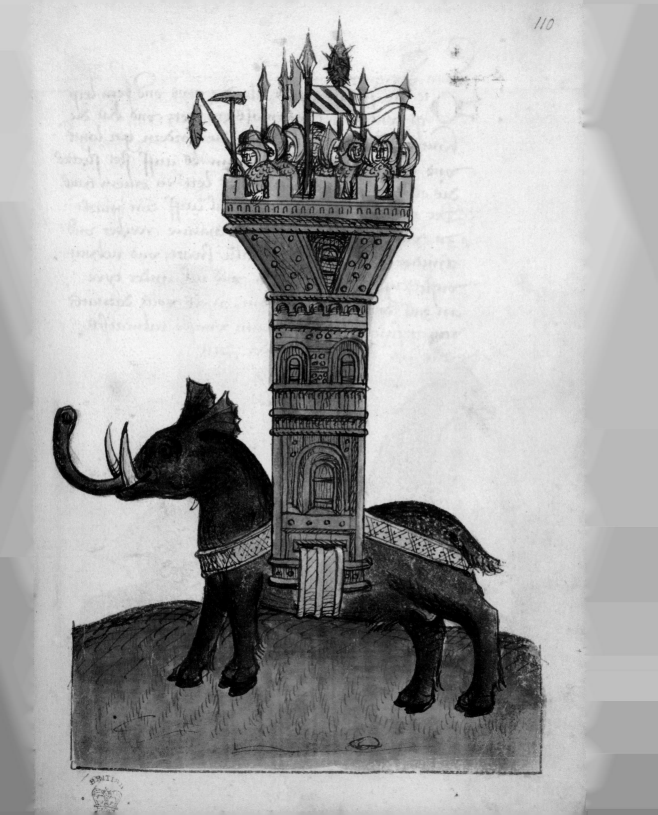

Men and women who led holy lives and often died defending their faith were a favorite devotional focus for medieval Christians. The stories told about these saints were often translated into images by reducing details from the narrative to a single symbol—such as a sword, a key, or a book—that served as a memory prompt for the larger story. In medieval portraits of the saints, these attributes were placed close to the holy person, helping viewers to identify the individual and providing an instant reminder of some key moment from the saint's life. During their time on earth all of these holy individuals must have encountered architecture, but for a select few, buildings were integral to the stories of their lives and deaths. Towers, churches, hermits' huts, and architects' tools all became saints' attributes.

Fig. 55 ◁
Saint Barbara
Master of Jacques of Luxembourg
Book of hours
Northern France or Flanders, ca. 1466–70
JPGM, Ms. Ludwig IX 11, fol. 136

The legend of Saint Barbara identifies her as the daughter of a rich man, Dioscorus, who locked her in a tower to preserve her from the prying eyes of men. Later, her father built her a bathhouse, to which she escaped as a sanctuary. Eventually, she refused to marry, revealing that she had become a Christian and preferred to devote her life to God, which caused her father to condemn her to death. Barbara appears here between her bathhouse hermitage and her tower jail, both of which exhibit the narrow windows and pointed, conical roofs found in medieval castle architecture.

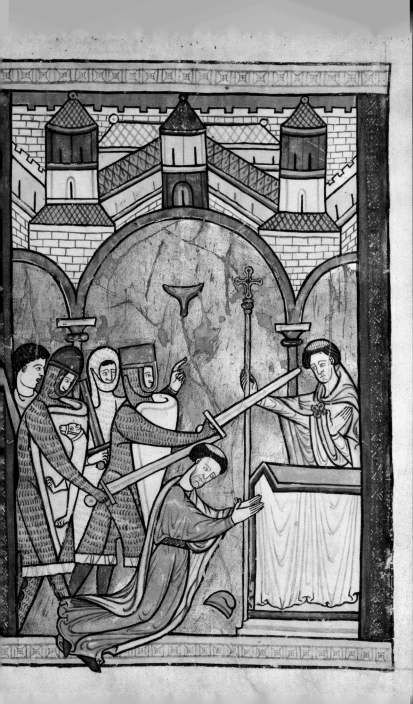

Fig. 56 ◁

The Martyrdom of Saint Thomas Becket
Miniature inserted into a psalter
England, last quarter of the 12th century
BL, Harley Ms. 5102, fol. 32

Thomas Becket, archbishop of Canterbury in the twelfth century, met his demise in the famous cathedral that he oversaw. After his dispute with King Henry II of England, four of the king's knights entered the church and murdered Saint Thomas, shown here being struck in the head with a sword as he kneels before the altar. His shocking death in a sacred architectural space was immortalized in imagery beginning almost immediately after his death in 1170, including in this early miniature, which was painted within a quarter century of his murder. The church setting for this scene, with its monumental rounded arches and cylindrical towers, reflects the Romanesque architectural style of Canterbury Cathedral in the twelfth century.

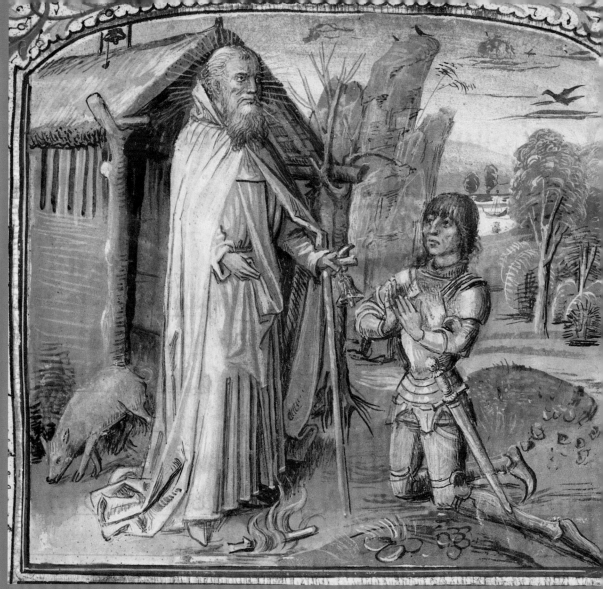

Fig. 57 △
A Knight Kneeling in Prayer before Saint Anthony and His Hermitage
Dreux Jean
The Invention and Translation of the Body of Saint Anthony
Brussels or Bruges, ca. 1465–70
JPGM, Ms. Ludwig XI 8, fol. 50

Before the development of large monastic communities in Europe in the sixth century, the earliest Christian monks lived as hermits in solitary dwellings often situated in harsh climates. Saint Anthony, one of the most famous of these "desert fathers," set up a simple hermitage in Egypt, where he endured various tortures at the hands of the devil, and his strong faith soon attracted followers. He is shown here in the wilderness, standing in front of his simple cottage, with its roof supported on a frame constructed from rough-hewn tree trunks. Kneeling at Anthony's feet is a knight, probably the manuscript's owner, demonstrating his devotion to the saint.

Understood to possess a direct line of communication from her mouth to God's ear, the Virgin Mary stood at the pinnacle of all saintly intercessors on behalf of medieval Christians. Over the course of the Middle Ages devotion to the Virgin grew increasingly strong, not just because of her role as the mother of Christ but for her own sake, as an interest in her life and even her emotions was spun into myriad well-known and well-loved stories in the centuries after her death. As theologians contemplated and discussed Mary, her symbolic meaning expanded, particularly the powerful association of the Virgin with the Church. In texts she was referred to as *ecclesia* (Latin for "church"), and images cemented this connection by depicting her next to or within church structures. These religious buildings were some of the greatest achievements of medieval architecture, and they served as fitting symbols for such an important figure as the mother of Christ.

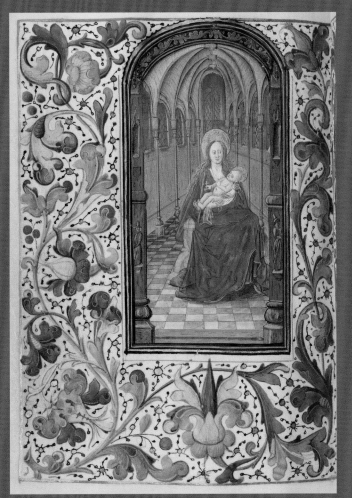

Fig. 58 ▷
The Virgin and Child Enthroned in a Church
Book of hours
Probably Ghent, ca. 1450–55
JPGM, Ms. 2, fol. 243v

As a Jewish woman who lived more than eleven centuries before the construction of the first Gothic cathedral, Mary would never have occupied a space such as this. She sits enthroned in the central nave of a late medieval church with a high, groin-vaulted ceiling and numerous windows. Her massive form nearly spans the width of the nave, and her head reaches to the level of the clerestory windows at the top of the wall. Her monumental scale—too large to be naturalistic—associates her with the church building itself, visually expressing her role as *ecclesia* without saying a word.

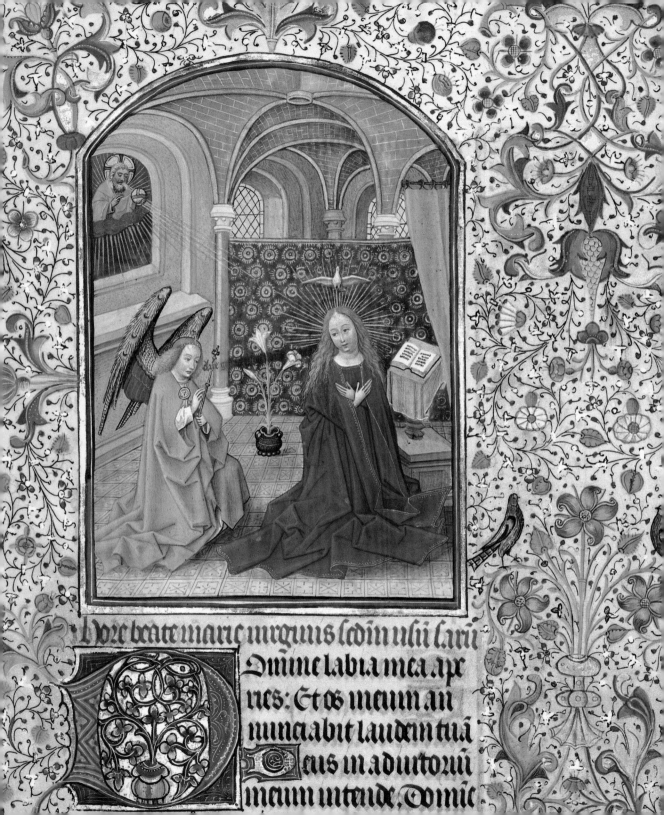

ore beate marie urgims fedm ulu farū

Omine labia mea ape
ries: Et os meum an
nunciabit laudem tua
Deus in adiutoriū
meum intende. Domie

Fig. 59 ◁
The Annunciation
Willem Vrelant
Arenberg Hours
Bruges, early 1460s
JPGM, Ms. Ludwig IX 8, fol. 58

Fig. 60 ▷
The Virgin, or Ecclesia, Holding a Staff and a Church
Neville of Hornby Hours
London (?), second quarter of the 14th century
BL, Egerton Ms. 2781, fol. 17

In a fashion similar to the portrayal of medieval images of saints with their symbols or attributes, this haloed female figure with a cross-topped staff holds a small model of a church with a chalice and Communion wafer at the center. Although she is not accompanied by an inscription, the miniature church identifies her as either the allegorical figure of *ecclesia* or, by association, Mary herself. She proffers the building to a group of Jesus' apostles, urging them to spread the teachings of Christ, and perhaps also church architecture, throughout the world.

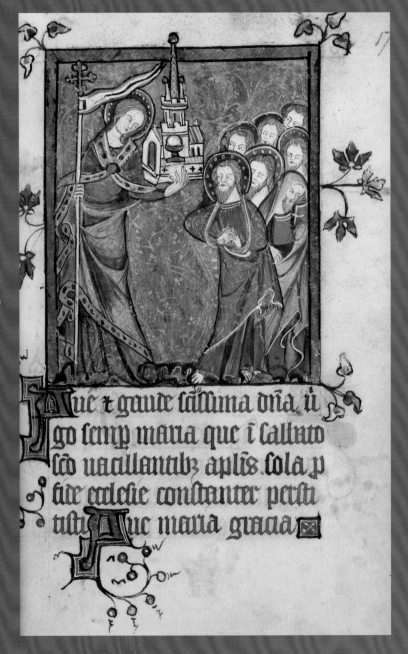

Focus: Architecture Takes Center Stage

In his illustrations for the Prayer Book of Cardinal Albrecht of Brandenburg, Simon Bening drew architecture out of the biblical stories he depicted and placed it directly in the spotlight. Buildings loom large in his various scenes from Christ's life, and in some cases they even distract from the events taking place in and around these spaces and structures. The artist rendered these edifices as complex combinations of elements drawn from Roman, medieval, and Renaissance architecture. These impressive buildings are at once highly naturalistic and cleverly manipulated to convey the symbolic meaning of the story portrayed.

Prayer Book of Cardinal Albrecht of Brandenburg
Simon Bening
Bruges, ca. 1525–30
JPGM, Ms. Ludwig IX 19

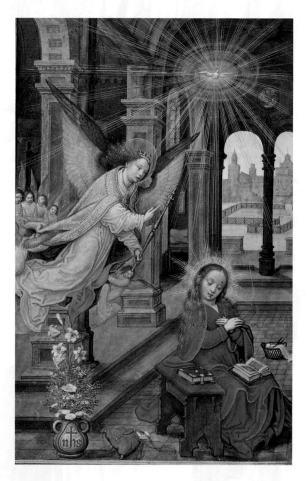

Fig. 61 ◁
The Annunciation
fol. 13v

In medieval imagery the archangel Gabriel's annunciation to Mary that she will give birth to Christ typically takes place either in a domestic interior (fig. 15) or in a churchlike setting, as in this example. The forms of classically-inspired Renaissance architecture abound here—thick, marble-inlaid pilasters support rounded arches and a coffered ceiling. With its back wall an open arcade, the space has the feeling of an airy portico that Gabriel and his attendant angels can enter easily, interrupting the pious Mary as she reads her prayer book. The structure also provides a tantalizing view of the Virgin's hometown of Nazareth that lies beyond.

Fig. 62 ◁
The Nativity
fol. 19v

The architecture in the background of this scene of Christ's birth resembles a ruined version of the churchlike setting of the Annunciation miniature in this manuscript (fig. 61). The arcaded structure lacks a roof, weeds grow from the tops of the walls, and only the base of a column remains at the lower right of the image. The Gospel of Luke tells us that, unable to find room at the inn, Mary gave birth to Jesus in a stable, and the dilapidated architecture depicted here, while not a barn, evokes this modest outdoor setting. The massive, decorated columns and the tall, wide archways suggest a building that, although now in ruins, was once grand, reflecting Christ's majesty. Most miniatures in this manuscript are framed by an unadorned, rectangular border, but in this example gold columns decorated with sculpture frame the central image, conveying the majesty and import of the birth of Christ.

Fig. 63 ▷
The Circumcision
fol. 28v

This scene of Christ's circumcision takes place in the temple sanctuary, shown here as a vaulted baldacchino, or architectural canopy, raised on columns. The structure is curtained off, allowing access only to a small, privileged group of people, including Jesus' family and the rabbi. Although the curtains are drawn back along the front of the structure, two thick columns in the foreground awkwardly cut through the scene, partially obstructing our view of the event. The architecture thus creates an almost voyeuristic perspective on the ritual, heightening our sense of the intimacy and holiness of this moment.

Fig. 64 ◁
Christ among the Doctors
fol. 53v

This fantastical hexagonal structure represents the temple in Jerusalem, where Christ's worried parents found the missing twelve-year-old Jesus conversing with the learned elders. This building recalls Renaissance *tempietti*, chapel structures that were often cylindrical, with open archways around their exterior. The medallions containing classical equestrian figures on each side of the building's upper wall further suggest the Renaissance interest in ancient art and architecture. The structure also incorporates an impressive fan vault, a late medieval architectural innovation in which all the vault's ribs spring from a single central column—in this case the pillar directly under which Jesus is seated, so that all the ribs lead to Christ.

Fig. 65 ▷
Christ Washing the Apostles' Feet
fol. 87v

After finishing his final Passover meal, Christ rose from the dinner table and proceeded to wash his apostles' feet as a sign that: "no servant is greater than his master, nor is a messenger greater than the one who sent him." The artist has interpreted the room in which the Last Supper was held as the vast banquet hall of a medieval palace. He calls attention to the room itself by depicting a high, vaulted wood ceiling that dwarfs the event taking place below it. Additional features, like horizontal support bars for the vault and the three-paneled devotional painting at the back wall over the fireplace, are elements that would have been found in massive rooms in wealthy households.

Fig. 66 ◁
The Flagellation
fol. 154v

During his Passion, Christ was tortured and beaten. In this rendition, the event takes place within a grand space evoking both classical architecture and Italian Renaissance buildings based on the forms of ancient Roman constructions. In medieval depictions of the Flagellation, artists tended to focus on the single element of the column, one of the basic building blocks of architecture. It was this column that eventually became one of the *arma Christi*, or symbols of Christ's Passion, which came to be a common motif in medieval imagery. Although surrounded by his tormenters, Christ stands isolated so as to convey the full extent of his suffering. The bright green marble of the column contrasts strongly with the rest of the drab gray architecture, further drawing the viewer's eye to Christ at the center of this vortex of abuse.

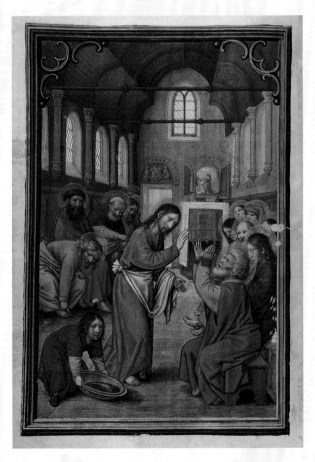

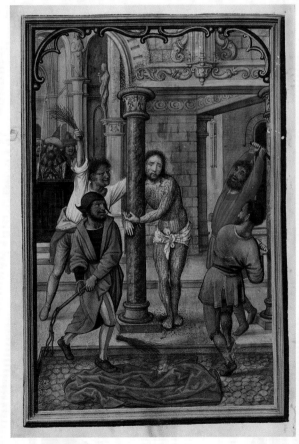

ARCHITECTURE BEYOND BUILDINGS

Architecture permeated the medieval world so deeply that artists not only reproduced the various types of buildings that surrounded them but also cut and pasted various architectural elements into compositions for purely decorative purposes. Elements such as columns, arches, vaults, tracery, and carved niches appear in the margins and frames around texts and images, enshrining them within the beautiful forms of Romanesque, Gothic, and Renaissance architecture. These bits of buildings do not make sense as stand-alone structures; rather, they were exploited for their aesthetic value and to suggest the grandeur of the edifices to which they originally belonged. For example, a classically inspired arch frames a proud aristocrat (fig. 74), and fortified towers decorated with symbols of the Holy Roman Empire flank a carefully constructed letter in a model book of calligraphy (fig. 68). Even complete structures were sometimes transformed by medieval artists from realistic buildings into abstract stage sets for depicting narratives. Recognizing the flexibility of architectural elements, artists extracted and rearranged these forms like children's building blocks to tell stories and convey symbolic meaning.

POVR LA CORNETTE DE MONSEIGNEV
LE DAVPHIN.

VN Lionceau qui regarde un Lion tenant un Tygre abatu fous
Avec ce mot EX PATRE VIRTVTEM ADDISCAM, pour dire
Monfeigneur le DAVPHIN ne peut eftre qu'un Prince redoutal
dans la guerre, puis qu'il doit faire fon apprentiffage dans l'efcolle d
auffi grand Maiftre que fa Majefté.

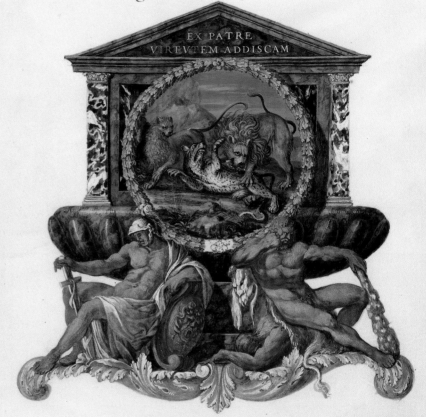

DISTICHON

SI pergas graue Martis opus tolerare Magistro
Sub patre, post patrem par tibi nullus erit.

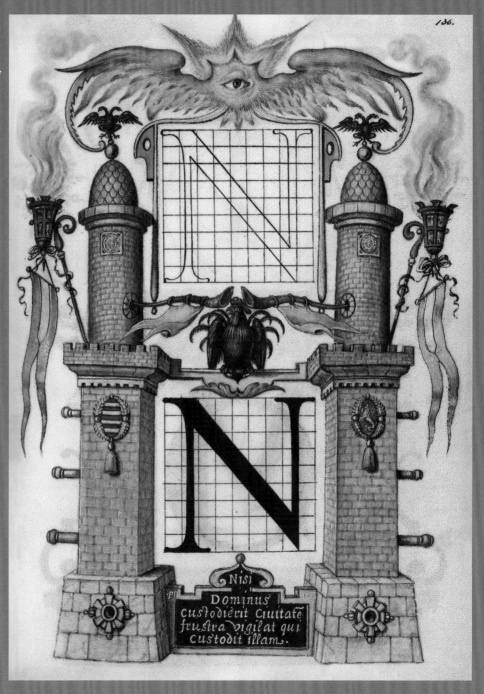

Fig. 67 ◁
Emblem with a Pediment Motif
[Escutcheon with a Lion Attacking a Cheetah]
Jacques Bailly
Nine Emblems for Louis XIV
Paris, ca. 1663–68
JPGM, Ms. 11, leaf 4, recto

Fig. 68 ▷
Guide for Constructing the Letter N
Joris Hoefnagel
Model Book of Calligraphy
Vienna, ca. 1591–96
JPGM, Ms. 20, fol. 136

As the decoration of manuscripts became increasingly elaborate in the late Middle Ages, artists delighted not just in creating miniatures depicting various scenes but also developed endless varieties of patterned borders to frame both text and image. Architecture was one fertile field for their artistic imagination, and various forms drawn from buildings appear frequently in the borders of manuscript pages. These architectural frames sometimes had no thematic relationship to the image or text they surrounded, but the fact that the delicate and complex forms of architecture share the page with important texts and images tells us something about the high regard in which these constructed forms were held at the time.

Fig. 69 ◁
Architectural Border
[The Virgin and Child Enthroned]
Master of James IV of Scotland
Spinola Hours
Bruges and Ghent, ca. 1510–20
JPGM, Ms. Ludwig IX 18, fol. 64v

The artist who painted this scene delighted in layering various architectural elements and materials. The forms that fill the borders of this miniature are executed in brown pigment with gold highlights, suggesting the carved woodwork that covered the walls of many late medieval churches in Europe. The large rounded arch that frames the miniature and the convex shape of the columned structure below the text suggest a stage. This setting presents to the viewer a scene of the Virgin and Child seated in a vaulted stone architectural space and surrounded by angels and women kneeling in prayer. At the same time, the outermost parts of the frame curve inward like arms, enveloping the viewer and drawing him or her further into this scene. This particular border device recalls the appearance of both an intricately carved wood frame around a painted altarpiece and a window into the sort of rib-vaulted church space familiar to a pious late medieval viewer.

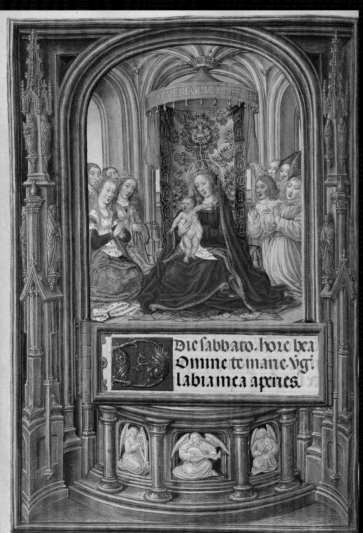

Fig. 70 ◁
Architectural Border
[Decorated Text Page]
Simon Bening
Prayer Book of Cardinal Albrecht of
Brandenburg
Bruges, ca. 1525–30
JPGM, Ms. Ludwig IX 19, fol. 144

The architecture that fills the border
of this page has been rendered in
minute, naturalistic detail. Late
medieval churches were decorated
inside and out with intricately carved
stone and wood sculpture, including
statues of various saints and prophets,
as suggested here by the figures
inhabiting the right side of the frame.
These sculptures were often embed-
ded in tracery—a light, delicate, and
finely carved framework based on the
architectural elements of the larger
church structure.

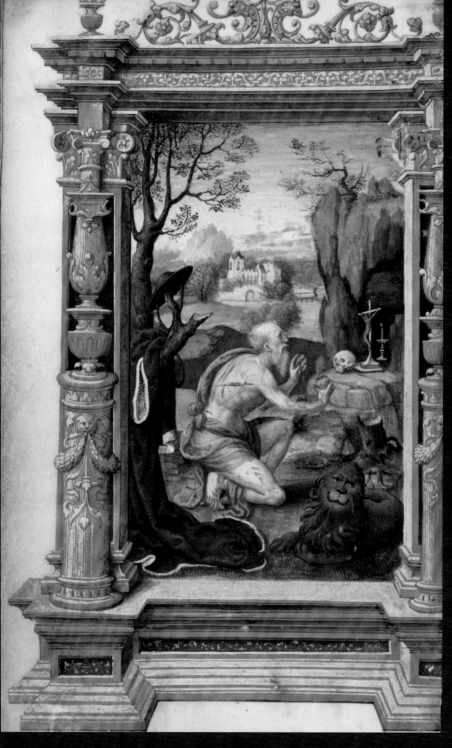

Fig. 71 ◁
Architectural Frame
[Saint Jerome]
Master of the Getty Epistles
Getty Epistles
France, ca. 1520–30
JPGM, Ms. Ludwig I 15, fol. 1v

Surrounding this portrait of Saint Jerome is an imposing architectural frame composed of multilevel columns supporting a projecting cornice and adorned with Renaissance decorative motifs, such as acanthus leaves and foliate swags. Contrasting with these elaborate, man-made architectural forms is the naturalistically depicted rocky landscape within which Saint Jerome kneels in prayer. In the background immediately above his head, however, is a church structure with an extended nave and a tall tower, providing a recognizable point of reference for the medieval Christian reader of this book and a reminder of Jerome's importance as one of the leading theologians of the Church.

Fig. 72 ▷
Architectural Border
[Adoration of the Shepherds]
Amico Aspertini
Hours of Bonaparte Ghislieri
Bologna, ca. 1500
BL, Yates Thompson Ms. 29, fol. 15v

The borders of this page teem with minute decorative details, including birds, hybrid creatures, cherubs, armor, and gem-studded jewelry. Embedded in the lower margin is an open porch drawn from classical architecture and depicted in realistic perspective. These motifs were likely inspired by the paintings that cover the walls of the Domus Aurea, the golden house of the Roman emperor Nero, which was rediscovered at the end of the fifteenth century, when this manuscript was made.

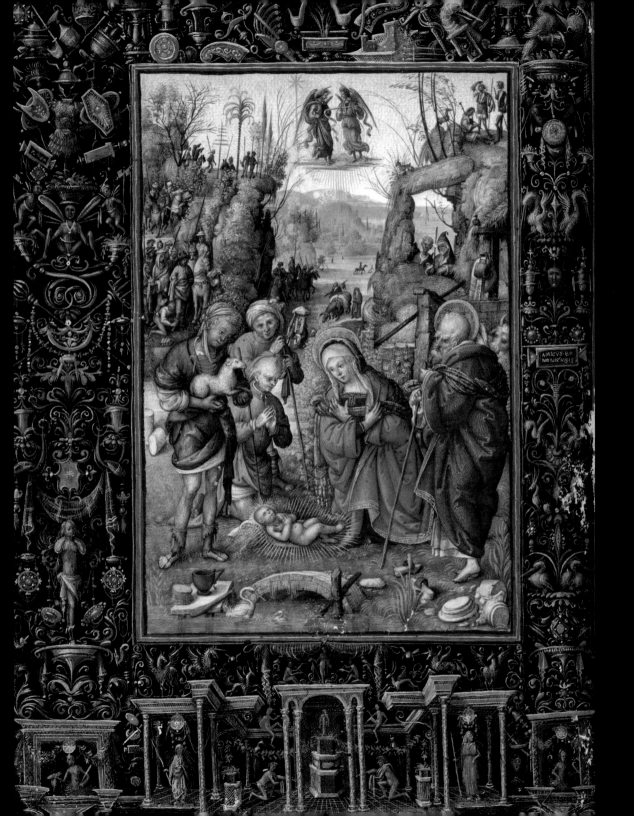

AMICVS·BO
NONIENSIS

As one of the basic building blocks of architecture, the arch came into its own in the Roman period as an ideal means of spanning increasingly larger spaces and supporting heavy superstructures. The strength and rounded elegance of the arch structure lent themselves well to the triumphal arch, a style of monument developed during the Roman Empire to commemorate rulers (fig. 73). Triumphal arches were stand-alone archways enlarged and covered with sculpture and inscriptions declaring the glory of various Roman leaders, and they can be seen dotting the urban landscape of Rome even today. Later, medieval artists drew upon the form of the triumphal arch to frame portraits of various important people, and they extended the symbolic value of the triumphal arch to other architectural elements, such as individual vaults and niches. All of these architectural forms were used to glorify a particular saint or ruler and to underscore his or her power and greatness.

Fig. 73 ▽
**The Arch of
Constantine, Rome**
Albumen silver print
Rome, 1860
JPGM, 84.XM.885.1.31

1324.

[Handwritten text in old German script, largely illegible]

Grat Friz der Elter, damals grave Oftertag gehaiten, am Sone des ongerannden von Zollern, Ift am frolicher Raftmveileger, bey mengeliech am angenommet, Mam gemest, und lieb gehabt, Difer hat am Vetter oder Vatters Brueder gehabt, so zu Falingen gefeßen, der des ongenamten von Zollern Brueder gemest, und am ainigen Sone gehabt, Als aber er gern allein gemest, darumb die Brueder sechen zu samnten ßommen, noch geßriben, Und Ime sein ainiger Sohn ßurch hingangmgen, und gestorben, semen Vetre niechts aich Zor, darvon entzotten, Und als er sem Sohte von Falingen geen Groten, zu der Graven begrebnuß gefiert, hat er am Zu Ziehen, die Trimmen auß Zor goren gery, hat er als baldt Falingen, mit aller zugehore, dem von Wiertemberg zu kaußen geben, Und also ift Falingenn, vont namnen Zollen hinwegfß ßommen.

Difer grave hat nebend dem Friderich, noch zwen Sohn, namblich Friderich Köst der Friegenare, und grave Lameft, Findt man im Cünter zu Ingolftain, Anno, Drey Zehenhundert Dreißig, Margreth hat zwen Herren gehabt, Mabalena, am Graven von Monfackß.

Sem gemahel, Agnes Lamöt, Bienn die Nellebüng.

Fig. 74 ◁
Fritz Hohenzollern beneath a Triumphal Arch
Jörg Ziegler
Chronicle of the Hohenzollern Family
Augsburg or Rottenburg, ca. 1572
JPGM, Ms. Ludwig XIII 11, fol. 21

In this portrait of Fritz Hohenzollern from a manuscript that illustrates his family genealogy, the nobleman stands in a jaunty pose that effectively displays his elaborately decorated armor and his weapons, conveying both his power and wealth. Adding further to his grandeur is the large rounded arch under which he stands. The structure's simulated marble columns, the cherub at the top of the arch, and the acanthus leaf decoration of the arch and the column capitals all recall the appearance of triumphal arches, effectively equating this German aristocrat with the great rulers of the Roman Empire.

ARCHITECTURE BEYOND BUILDINGS | ARCHES AND NICHES

77

Fig. 75 ◁
Christ Blessing
Willem Vrelant
Arenberg Hours
Bruges, early 1460s
JPGM, Ms. Ludwig IX 8, fol. 34

Christ stands in a frontal, iconic pose hold-
ing an open book and raising his right hand
in a gesture of blessing. A rib-vaulted ceil-
ing supported on four columns rises above
him, suggesting a church interior. At the
same time, the structure itself is an unusual
open-air pavilion that permits a sweeping
view of the surrounding countryside with
its castles. By placing Christ at dead center
of a fictional structure that combines views
of both sacred and secular architecture, the
artist conveys Christ's dominion over all
aspects of medieval life.

Fig. 76 ▷
The Presentation in the Temple
Workshop of the Bedford Master
Book of hours
Paris, ca. 1440–50
JPGM, Ms. Ludwig IX 6, fol. 83

This scene of Mary presenting the Christ
child to the rabbi Simeon is set within a
space that resembles a church interior, with
a vaulted ceiling and clerestory windows set
high on the walls. The artist has rendered
the archway through which we view the
event in sparkling gold leaf, setting it off
from the rest of the building. It becomes
a kind of triumphal arch around the most
important figures in the story, especially
Christ, who is situated in the very center.

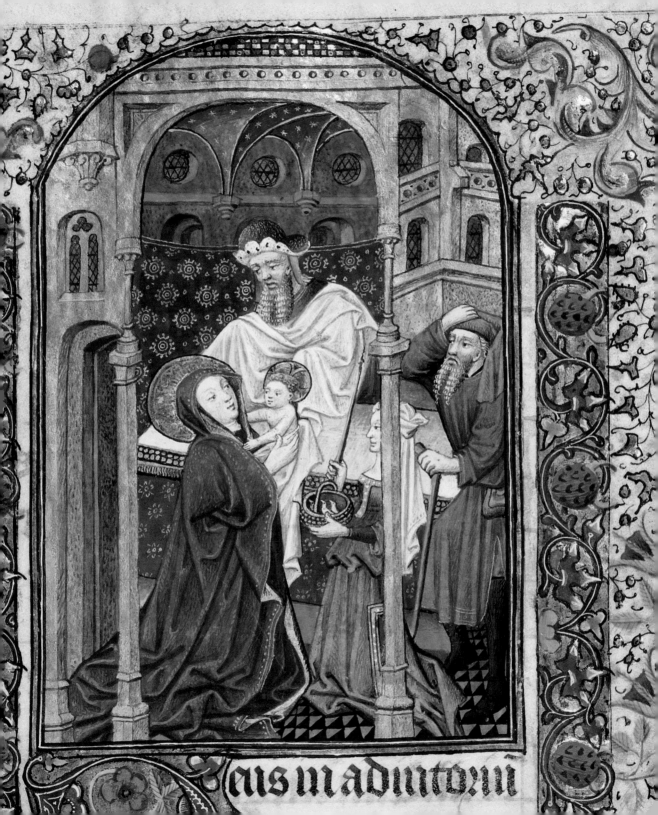

Fig. 77 ▽
Saint Nicholas
Taddeo Crivelli
Gualenghi-d'Este Hours
Ferrara, ca. 1469
JPGM, Ms. Ludwig IX 13, fol. 178v

The bearded bishop squeezed like a trinket into this shadow box–like pavilion was the inspiration for the figure we know today as Santa Claus. Saint Nicholas generously provided marriage dowries for three virgins (note the three round moneybags he holds in his right hand),

and thereafter he became celebrated as a gift giver. The closet-sized marble structure in which the saint stands recalls an *aedicula*—a type of small Roman shrine. Its triangular, pedimented roof and the checkerboard of coffers across its ceiling recall both Roman architecture and Italian Renaissance architecture based on earlier Roman forms. As the devotional focus of this page, Saint Nicholas is enclosed within a compact space, much like a statue of a saint enshrined within a niche inside a Renaissance church.

Fig. 78 ▷
Saint Hedwig of Silesia with Duke Ludwig I of Liegnitz and Brieg and Duchess Agnes
Court Workshop of Duke Ludwig I of Liegnitz and Brieg
The Life of the Blessed Hedwig
Silesia, 1353
JPGM, Ms. Ludwig XI 7, fol. 12v

In this illustrated life of Saint Hedwig, the artist chose an architectural setting for the saint's main portrait. This space recalls a shallow niche of the sort that appears in churches to house sculptures of saints. The much smaller figures of Duke Ludwig I and Duchess Agnes, who commissioned the creation of this manuscript, kneel to each side of Hedwig, shaded by architectural overhangs. These elements mirror the minutely detailed architectural stone canopies that shelter the figures of saints and prophets on the facades of Gothic churches of around this time (fig. 79). This elaborate framing device, drawn from sacred architecture, therefore honors both Saint Hedwig and the wealthy patrons who sponsored the writing and illustration of her life story.

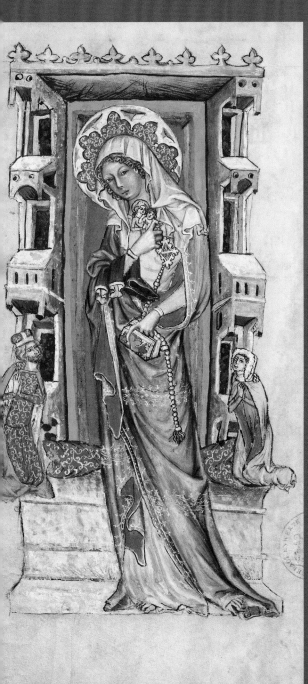

Fig. 79 △
The Tower of the Kings at Rheims
Henri Jean-Louis Le Secq
Salted paper print
Rheims, 1851
JPGM, 84.XP.370.25

In addition to prose and poetic passages, medieval manuscripts often contained charts and indices, just like our modern books. For example, Gospel books, containing the four New Testament books of Matthew, Mark, Luke, and John, typically featured canon tables—charts that helped the reader find the same story across two or more Gospels. Unlike the dull spreadsheets we rely on today, medieval artists livened up these canon tables with painted decoration, often using architectural forms to structure the information they contained. The painted archways that framed these charts are reminiscent of gateways, reflecting the purpose of the information they contain—to offer readers an entry point into the texts within the manuscript.

Fig. 80 ◁
Canon Table Page
New Testament
France, probably the Cistercian Abbey
of Pontigny, ca. 1170
JPGM, Ms. Ludwig I 4, fol. 16v

This page displays the ninth and tenth canon tables in a series of ten—the ninth comparing the Gospels of Luke and John, and the tenth listing stories that are particular to only one Gospel. A succession of tall, slender arches creates columns organizing this information. This manuscript was probably made in Pontigny, a Cistercian monastery that followed the reforms instituted by Saint Bernard of Clairvaux (fig. 23). The elegant proportions of the arcades in these canon tables and their relatively restrained decoration mirror the austere interior of the church at Pontigny, which was built in adherence to Bernard's injunction against excessive embellishment of monastic churches and cloisters.

King Ezana established Christianity as the official religion of the kingdom of Ethiopia in the fourth century A.D. As in Europe, the basis for the Ethiopian ceremony of the mass was the four Gospels, and a constant feature of Ethiopian Gospel books was a set of canon tables that introduced the text. Unlike the spare forms of the Pontigny canon tables, this example displays three brightly colored columns that support an elaborate pair of arches formed by concentric half-circles. Abstract knot-work patterns adorn the archways, recalling Celtic interlace motifs, and the curled elements that support the column capitals may allude to the spiral volutes of the Ionic-style columns found in classical architecture. Nonetheless, the main architectural framework is so buried under bold decorative details that it nearly vanishes into the overall pattern. Between the columns are the numbers identifying the different Gospel stories. Here, they are written in Ge'ez, the language used in the Ethiopian church liturgy, just as Latin was used in church ceremonies in Europe.

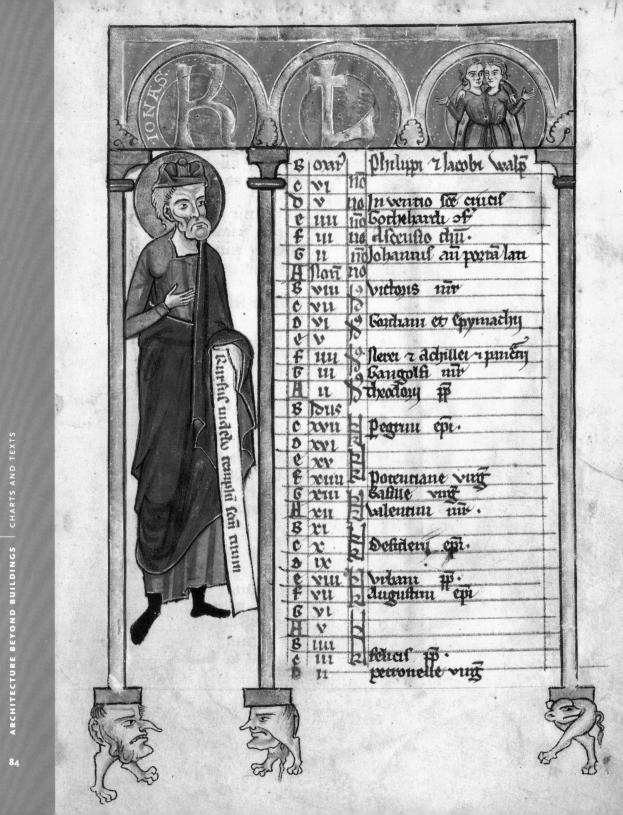

Fig. 82 ◁
June Calendar Page with Architectural Frame
Psalter
Würzburg, ca. 1240–50
JPGM, Ms. Ludwig VIII 2, fol. 3

The architectural frame around this calendar for June was built upon the backs of animals. The strange hybrid creatures that support the columns not only add a whimsical element to the highly structured page, they also directly reflect the decoration found on column bases and capitals in medieval buildings.

Fig. 83 ▷
Architectural Frame
[Decorated Monogram *IN*]
Gospel lectionary
St. Gall or Reichenau, late 10th century
JPGM, Ms. 16, fol. 4v

The large gold and silver arch on this page frames the intertwined initials *I* and *N*, which form the first word in the Gospel of John—the opening phrase is, *In Principio erat verbum* (In the beginning was the Word). The resulting monogram, decorated with plant tendrils and the head of an animal, highlights the beginning of John's text, which tells the story of Christ's birth. In illuminated manuscripts produced during the Ottonian Empire in Germany, such as this Gospel lectionary, the first words of the most important passages were richly decorated so that words themselves often became an image. The use of a decorated archway around the monogram here further monumentalizes the text and recalls the form of the triumphal arch. The medieval scribe understood the power of this architectural element and used it to highlight this text, which was read on Christmas, one of the most important feasts of the Christian liturgical year.

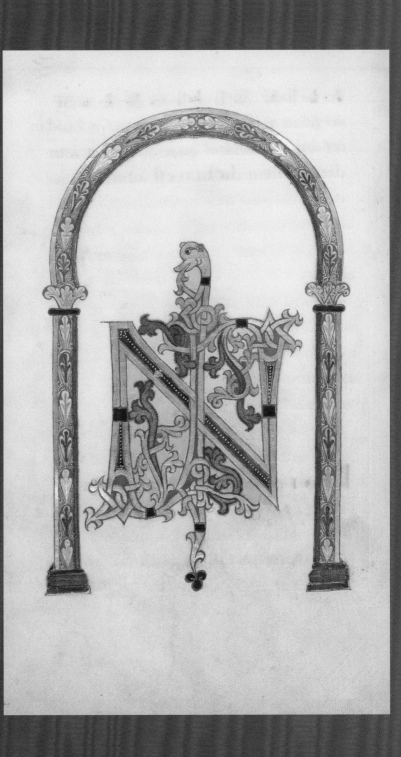

Medieval artists were well aware of the great capacity of architecture as an aid to storytelling. The multiple rooms and spaces within many medieval buildings made them the ideal stage set for narratives. Several episodes from a story could be depicted on a single page when placed in and around the various chambers of a house or the different spaces within a church. Arranging various moments from a story running from room to room in a building can also create a sense of suspense in the narrative or show both a conflict and its resolution. Finally, the often rhythmic forms of medieval buildings with their repeated architectural elements can also effectively depict images of processions or convey a measured progression of time.

Fig. 84 ▷
The Prodigal Son at the Brothel
Workshop of Dieboldt Lauber
Rudolf von Ems, *Barlaam and Josaphat*
Hagenau, 1469
JPGM, Ms. Ludwig XV 9, fol. 106

Riches to rags tales date back to the Bible. The parable of the prodigal son is the story of a wealthy young man who squandered his inheritance. This late medieval German image of the man's transformation plays out in and around a castlelike structure representing a brothel. Dressed in the fashionable costume of a wealthy nobleman, the prodigal son is lured by a comely lady through the door of the building. After spending all the money he has on the pleasures of the brothel, he hastily exits through a second door in bedraggled clothing as three inhabitants of the brothel chase him out with a broom, a pitchfork, and a spindle used for spinning wool. The use of the entrance and exit doors of the building effectively conveys the cause-and-effect moral of this story.

Fig. 85 ▽
The Story of Adam and Eve
Boucicaut Master
Giovanni Boccaccio, *Concerning the Fates of Illustrious Men and Women*
Paris, ca. 1415
JPGM, Ms. 63, fol. 3

Boccaccio's book about famous individuals throughout history begins where it all began—with the story of Adam and Eve.

The Boucicaut Master created a Garden of Eden confined by a hexagonal enclosure with a gate (at left) and a tower (at right) that look just like the fortified walls of a medieval castle. This structure allowed the artist to show each step of the story in a series of events that spirals outward from the center of the composition. The tale begins at the middle of the garden, where Eve is shown accepting the apple from the serpent, and the results are shown at left as an angry angel with a sword shoves Adam and Eve through the turreted gate. Now outside and behind the wall, they meet their fate: Adam must labor in the fields and Eve must spin wool. In the foreground they are shown years later as an elderly couple hobbling around the front of the wall toward Boccaccio, who has recorded their lives in his open book, bringing the story full circle.

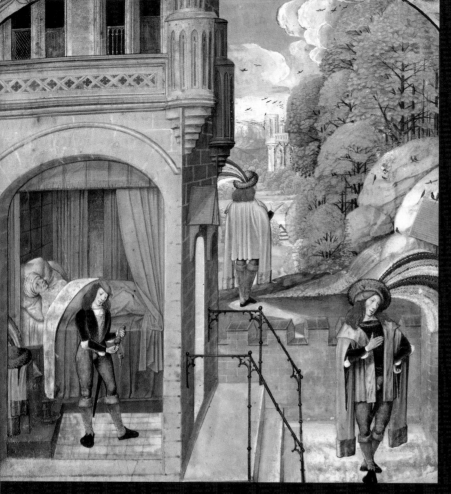

Fig. 87 ▷
Cistercian Nuns Attend Mass
The Holy Abbey
Paris or Maubuisson (?) or Lorraine, ca. 1290
BL, Yates Thompson Ms. 11, fol. 6v

This manuscript, which contains various texts for use in the education of nuns, was probably made for the Cistercian convent of Notre-Dame-la-Royale in Maubuisson. The miniatures in the book offer representations of the ideal nunnery. In this image, the cloistered women are shown participating in two liturgical ceremonies. In the upper register they file into the long nave of a Gothic church to attend mass, and below they follow a priest and deacon in a religious procession beneath a row of cusped arches (perhaps depicting the crypt). The running arcades in each register reflect not only the typical setting for these ceremonies but also the highly organized and progressive nature of both events.

Fig. 86 △
The Beginning of the Dream
Master of the Prayer Books of ca. 1500
Guillaume de Lorris and Jean de Meun,
Romance of the Rose
Bruges, ca. 1490–1500
BL, Harley Ms. 4425, fol. 7

The *Romance of the Rose* begins by describing the dream of a lover who imagines a beautiful rose, symbolizing his beloved, trapped in a castle. Here, different indoor and outdoor spaces allow several sequential events from the story to be depicted simultaneously. At left, the lover soundly snoozes in the bedroom of his lavish home; at right, he appears foppishly dressed in his courtly best, outside the castle but within the walls of his property, ready to embark on a walk; and in the background he strolls off into the countryside toward the Garden of Love, where he will encounter the various vices of women.

Focus: Architecture Abstracted

In the high Middle Ages in Germany, the massive rounded arches, barrel vaults, and cylindrical towers of Romanesque architecture formed the foundation for church design. The artist who illustrated the Stammheim Missal, a priest's book of prayers for the mass written for the church of Saint Michael at Hildesheim, built the images that he painted upon these impressive forms. Beginning on the very first pages of this manuscript, which display a twelve-page calendar of various feasts throughout the year, one of the main building blocks of architecture takes a starring role. As were the canon tables, calendars and other texts found in German liturgical books were often framed by the iconic arch. Later in the book, for the miniatures that illustrated the mass texts for these feasts, the artist manipulated architecture to structure the scenes he created. The monumental forms of Romanesque buildings were often the perfect organizing elements for the compartmentalized compositions typical of illumination in this period. None of the architecture that fills the pages of this manuscript is recognizable as one specific building or another, but these abstract elements nevertheless convey the indelible stamp architecture left on the worldview of the monks at Hildesheim.

Stammheim Missal
Hildesheim, ca. 1170s
JPGM, Ms. 64

Fig. 88 ◁
May Calendar Page with Architectural Border
fol. 5v

The Christian feasts celebrated in the month of May are listed on this page underneath a simple golden arch. Piled onto the corners of the structure are the abbreviated forms of buildings with red tile roofs, semicircular apses, and picket fences—an odd combination of elements drawn from both sacred and secular architecture. The entries on each calendar page in this manuscript are similarly framed by a large arch, and several of these arches are decorated with additional architectural elements, creating a complex layering of constructed forms.

Fig. 89 ▷
Decorated Text Page
fol. 61

One section of this manuscript contains musical texts used in the mass, which are accompanied by an early form of musical notation called neumes. In a variation on the calendar decoration, these hymns are framed by a double arch. On this page the archway is both naturalistic (the fine white vertical line gives the effect of light hitting a curved, polished marble column) and abstract (the brightly colored zigzag pattern on the outermost columns). Some of these large frames are further embellished with architectural elements drawn from medieval buildings. The tower with a crenellated roof, which sits where the two arches meet, is depicted in perspective so as to give a sense of the structure's cylindrical form.

Fig. 90 ◁
The Annunciation
fol. 11v

Early medieval scenes of the Annunciation often depict the archangel Gabriel and the Virgin Mary conversing across a double-arched space that both isolates the two figures and enshrines them. Here that construction is further embedded within a dense and abstract architectural structure from which we can pick out rows of colorful masonry blocks; sets of narrow, arched windows; and three towers containing, from left to right, the important biblical figures of King David, Aaron, and Saint Paul. The inscriptions below King David and Paul, and also beneath King Solomon, who appears at the bottom of the image, all refer to symbolic architectural themes, such as the City of God, the House of Wisdom with its seven pillars, and Christ as the foundation of the Church.

Fig. 91 ▷
Saint Bernward of Hildesheim
fol. 156

In addition to its use by a priest when saying the mass, the Stammheim Missal was also a book that the twelfth-century monks of Hildesheim used to commemorate their monastery's founder, Bishop Bernward. This image of Bernward within the church of Saint Michael surrounded by eight monks, was painted before he was officially canonized in 1193, but after the monks of Hildesheim were given permission to venerate him as a saint in 1150. One way in which they honored him was to visually enshrine him here within the basic, abstracted forms of the Romanesque church that he had built.

Fig. 92 ▷
Pentecost
fol. 117v

The bold forms depicted here are suggestive of the architecture of the time, but their abstract rendition gives the event an otherworldly, spiritual quality reminiscent of church buildings. Pentecost scenes appeared early on in German manuscripts, and as shown in later medieval images of Pentecost (figs. 10 and 45), the preferred setting for the event was a church. The apostles gather at the center of this miniature under a three-lobed archway, apparently the central nave that forms the core of a church. The other parts of the structure are more ambiguous, but the pair of towers at the top of the image suggests a *westwerk*, the massive, towered addition to the western end of Romanesque churches in Germany. The three arches at the bottom of the image resemble a vertical cross-section of a Romanesque nave flanked by two side aisles, the latter topped with angled roofs.

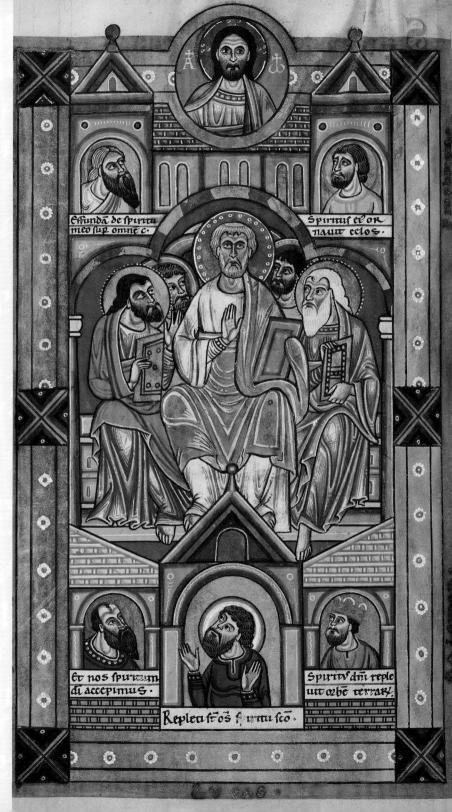

SUGGESTIONS FOR FURTHER READING

Bartlett, Robert. *Medieval Panorama* (Los Angeles, 2001).

Calkins, Robert G. *Medieval Architecture in Western Europe: From A.D. 300 to 1500* (New York, 1998).

Conant, Kenneth. *Carolingian and Romanesque Architecture, 800 to 1200*, 4th ed. (New Haven, Conn., 1993).

Erlande-Brandenburg, Alain. *Cathedrals and Castles: Building in the Middle Ages* (New York, 1995).

Kaufmann, J. E., and H. W. Kaufmann. *The Medieval Fortress: Castles, Forts, and Walled Cities of the Middle Ages* (Conshohocken, Penn., 2001).

Kren, Thomas. *Illuminated Manuscripts of Germany and Central Europe* (Los Angeles, 2009).

Prache, Anne. *Cathedrals of Europe* (Antwerp, 1999).

Reyerson, Kathryn, and Faye Powe. *The Medieval Castle: Romance and Reality* (Dubuque, Iowa, 1984).

Simson, Otto von. *The Gothic Cathedral: Origins of Gothic Architecture and the Medieval Concept of Order*, 3rd ed. (Princeton, N.J., 1988).

Stalley, Roger. *Early Medieval Architecture* (Oxford and New York, 1999).

Teviotdale, Elizabeth. *The Stammheim Missal* (Los Angeles, 2001).

Online Resources

Amiens Cathedral Project, run by Columbia University, http://www.learn.columbia.edu/Mcahweb/index-frame.html

St. Gall Monastery Plan, run by the University of California, Los Angeles, and the University of Virginia, http://www.stgallplan.org

THE MEDIEVAL IMAGINATION SERIES

The Medieval Imagination Series focuses on particular themes or subjects as represented in manuscript illuminations from the Middle Ages and the early Renaissance. Drawing upon the collections of the J. Paul Getty Museum and the British Library, the series provides a delightful and accessible introduction to the imagination of the medieval world. Future titles will cover other topics, including fashion and music.

Other volumes in the series:

Beasts Factual and Fantastic
Elizabeth Morrison

Faces of Power and Piety
Erik Inglis

Images in the Margins
Margot McIlwain Nishimura

ABOUT THE AUTHOR

Christine Sciacca is assistant curator in the Department of Manuscripts at the J. Paul Getty Museum. Her research interests include Italian and German manuscript illumination, and liturgy, patronage, and devotional practice. Dr. Sciacca completed graduate-level courses and fieldwork in medieval architectural history and has taught architectural history at Columbia University, where she completed her PhD. She has been a lecturer at the Cloisters Museum and served as a fellow at the Walters Art Museum.

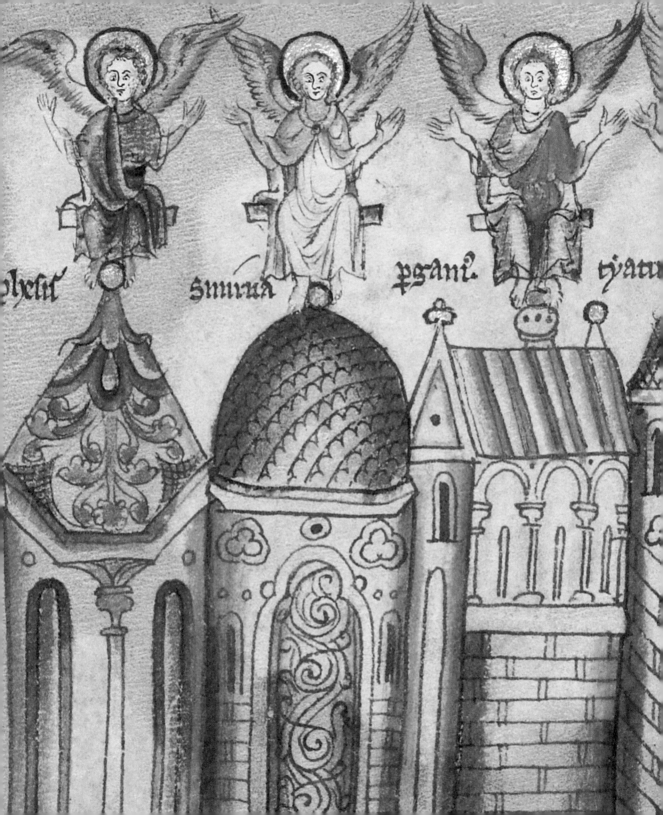